The Artist's Painting Library

OIL PAINTING

BY WENDON BLAKE / PAINTINGS BY GEORGE CHEREPOV

PITMAN PUBLISHING/LONDON

Copyright © 1979 by Billboard Ltd.

First published 1979 in the United States and Canada by Watson-Guptill Publications,
a division of Billboard Publications, Inc.,
1515 Broadway, New York, N.Y. 10036

Published in Great Britain by Pitman Publishing Ltd.,
39 Parker Street, London WC2B 5PB
ISBN 0-273-01418-8

Library of Congress Cataloging in Publication Data
Blake, Wendon.
 Oil painting.
 (His The artist's painting library)
 Originally published as pt. 1 of the author's
The oil painting book.
 1. Painting—Technique. I. Cherepov, George,
1909- II. Title. III. Series.
ND1500.B552 1979 751.4'5 79-11964
ISBN 0-8230-3271-X

Manufactured in U.S.A.

First Printing, 1979

CONTENTS

Painting in Oil. For centuries, oil paint has been the most popular painting medium—because it's the easiest. As it comes from the tube, the paint has a delightful, buttery consistency. When you dip your brush into that little mound of gleaming color on the palette and then make a stroke on the canvas, the color obeys your command immediately. The stroke stays exactly where you put it. It stays wet and waits for you to decide what to do next. You can spread the paint further, smooth it out, heap it up, blend another color into it, or scrape it off and start again. If you apply a thick stroke, it stands up from the canvas, and that bold stroke continues to stand up until it dries hard as leather. The buttery consistency of the tube color makes it easy (and fun) to mix on the palette with a brush or a knife. And you can make the paint as fluid as you like, simply by blending in a few drops of turpentine or oil with a knife or a brush.

What Is Oil Paint? Like every other kind of artists' colors, oil paint starts out as dry, colored powder, called pigment. The pigment is then blended with a vegetable oil called linseed oil—squeezed from the flax plant, whose fibers are also used to make linen. Together, the pigment and oil make a thick, luminous paste that the manufacturer packages in metal tubes. It's the oil that produces the buttery consistency that makes oil paint so easy to push around on the canvas. And the oil takes a long time to dry on the painting surface, giving you lots of time to work on the picture, to experiment, and to change your mind as often as you like. The linseed oil is called the *vehicle*. But there's another liquid which is equally important in oil painting: a *solvent* that will make the paint thinner and more fluid and then evaporate as the paint dries. This solvent is usually turpentine, though some painters use mineral spirits (or white spirit, as it's called in Britain), which works the same way and is worth trying if you're allergic to turpentine. Oil painters usually add a bit of linseed oil *and* a bit of turpentine to the tube color to make it more brushable.

Handling Oil Paint. The greatest pleasure of oil paint is the way it responds to the brush or the knife. If you paint with pure tube color—no extra oil or turpentine—you can pick up thick globs of paint on the brush or knife and lay on bold, richly textured strokes. If you add just a bit of linseed oil and turpentine, the paint takes on a creamy consistency ideal for more fluent brushwork. It's like spreading warm butter. The paint becomes so soft and pliable that you can blend one stroke or one color smoothly into another, producing beautiful gradations like colored smoke. With still more linseed oil and turpentine, the paint becomes fluid enough to paint crisp lines and precise details.

Drying Time. The gradual drying time of oil paint is one of its greatest advantages. The turpentine evaporates in minutes, but the oil remains and takes days to solidify to a tough, leathery film. Although some colors tend to dry faster than others, your painting does remain moist long enough for you to produce effects that aren't possible in any other medium. You can keep blending fresh color into the wet surface until you get the exact hue you want. You can go over a passage with a brush, stroke after stroke, until you produce exactly the rough or smooth texture you want. If you want a very soft transition between two areas of color—such as the light and shadow sides of a cheek or a cloud—you can smudge one color into another to produce a lovely, blurred edge. And if anything goes wrong, you can scrape away the wet color with a knife or wipe it off with a rag and start afresh.

Basic Techniques. In the pages that follow, the first thing you'll find will be a brief survey of the basic equipment you'll need for oil painting—tube colors, mediums, brushes, knives, easel, paintbox, palette, and other accessories. Then you'll see how oil paint looks on the two most common painting surfaces: canvas and a hardboard panel. You'll learn how to paint with bristle brushes, made of stiff, white hoghairs; with softhair brushes, made of sable, oxhair, squirrel hair, or nylon; with combinations of bristles and softhairs; and with the painting knife.

Painting Demonstrations. Then famed painter George Cherepov will demonstrate, step-by-step, how to paint eleven subjects—the sort of subjects you'll want to master. Cherepov will demonstrate the basic painting method with a very simple still life of vegetables from the kitchen. And since still life is the easiest subject to paint, he'll then show you how to paint a bowl of fruit, a vase of flowers, and a group of glass and metal bottles. He'll then proceed to an outdoor "still life" of rocks and wildflowers and move on to landscapes of the seasons: summer, autumn, and winter. He'll show you how to paint a male and female portrait head, and he'll conclude by demonstrating how to paint a coastal landscape.

Special Effects. Following the painting demonstrations, you'll learn three different ways to correct an oil painting—scraping and repainting, wiping out and repainting, and repainting a dry canvas. You'll learn special techniques such as impasto—which means working with thick paint—and scraping. You'll learn the tricky process of stretching a canvas. Finally, you'll learn how to take care of your painting equipment and how to varnish, frame, and preserve a finished oil painting so you can enjoy it for many years.

Color Selection. When you walk into an art supply store, you'll probably be dazzled by the number of different colors you can buy. There are far more tube colors than any artist can use. In reality, all the paintings in this book were done with just a dozen colors, about the average number used by most professionals. The colors listed below are really enough for a lifetime of painting. You'll notice that most colors are in pairs: two blues, two reds, two yellows, two browns. One member of each pair is bright, the other is subdued, giving you the greatest possible range of color mixtures.

Blues. Ultramarine blue is a dark, subdued hue with a faint hint of violet. Phthalocyanine blue is much more brilliant and has surprising tinting strength—which means that just a little goes a long way when you mix it with another color. So add phthalocyanine blue very gradually. These two blues will do almost every job. But George Cherepov likes to keep a tube of cobalt blue handy for painting skies and flesh tones; this is a beautiful, very delicate blue, which you can consider an "optional" color.

Reds. Cadmium red light is a fiery red with a hint of orange. All cadmium colors have tremendous tinting strength, so remember to add them to mixtures just a bit at a time. Alizarin crimson is a darker red and has a slightly violet cast.

Yellows. Cadmium yellow light is a dazzling, sunny yellow with tremendous tinting strength, like all the cadmiums. Yellow ochre is a soft, tannish tone. If your art supply store carries two shades of yellow ochre, buy the lighter one.

Browns. Burnt umber is a dark, somber brown. Burnt sienna is a coppery brown with a suggestion of orange.

Green. Although nature is full of greens—and so is your art supply store—you can mix an extraordinary variety of greens with the colors on your palette. But it *is* convenient to have just one green available in the tube. The most useful green is a bright, clear hue called viridian.

Black and White. The standard black, used by almost every oil painter, is ivory black. Buy either zinc white or titanium white; there's very little difference between them except for their chemical content. Be sure to buy the biggest tube of white sold in the store; you'll use lots of it.

Linseed Oil. Although the color in the tubes already contains linseed oil, the manufacturer adds only enough oil to produce a thick paste that you squeeze out in little mounds around the edge of your palette. When you start to paint, you'll probably prefer more fluid color. So buy a bottle of linseed oil and pour some into that little metal cup (or "dipper") clipped to the edge of your palette. You can then dip your brush into the oil, pick up some paint on the tip of the brush, and blend oil and paint together on your palette to produce the consistency you want.

Turpentine. Buy a big bottle of turpentine for two purposes. You'll want to fill that second metal cup, clipped to the edge of your palette, so that you can add a few drops of turpentine to the mixture of paint and linseed oil. This will make the paint even more fluid. The more turpentine you add, the more liquid the paint will become. Some oil painters like to premix linseed oil and turpentine, 50-50, in a bottle to make a thinner *painting medium*, as it's called. They keep the medium in one palette cup and pure turpentine in the other. For cleaning your brushes as you paint, pour some more turpentine into a jar about the size of your hand and keep this jar near the palette. Then, when you want to rinse out the color on your brush and pick up a fresh color, you simply swirl the brush around in the turpentine and wipe the bristles on a newspaper.

Painting Mediums. The simplest painting medium is the traditional 50-50 blend of linseed oil and turpentine. Many painters are satisfied to thin their paint with that medium for the rest of their lives. On the other hand, art supply stores do sell other mediums that you might like to try. Three of the most popular are damar, copal, and mastic painting mediums. These are usually a blend of a natural resin—called damar, copal, or mastic, as you might expect—plus some linseed oil and some turpentine. The resin is really a kind of varnish that adds luminosity to the paint and makes it dry more quickly. Once you've tried the traditional linseed oil-turpentine combination, you might like to experiment with one of the resinous mediums.

Other Solvents. If you can't get turpentine, you'll find that mineral spirits (the British call it white spirit) is a good alternative. You can use it to thin your colors and also to rinse your brushes as you work. Some painters use kerosene (called paraffin in Britain) for cleaning their brushes, but it's flammable and has a foul odor. Avoid it.

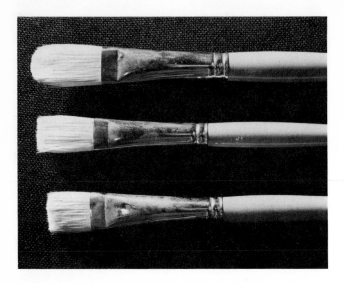

Bristle Brushes. The brushes most commonly used for oil painting are made of stiff, white hog bristles. The filbert (top) is long and springy, comes to a slightly rounded tip, and makes a soft stroke. The flat (center) is also long and springy, but it has a squarish tip and makes a more precise, rectangular stroke. The bright (bottom) also has a squarish tip and makes a rectangular stroke, but it's short and stiff, digging deeper into the paint and leaving a strongly textured stroke.

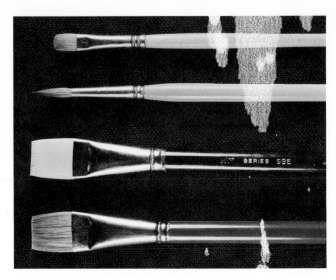

Softhair Brushes. Although bristle brushes do most of the work in oil painting, it's helpful to have some softhair brushes for smoother, more precise brushwork. The top two brushes here are sables: a small, flat brush that makes smooth, rectangular strokes; and a round, pointed brush that makes fluent lines for sketching in the picture and adding linear details such as leaves, branches, or eyebrows. At the bottom is an oxhair brush, and just above it is a soft, white nylon brush; both make broad, smooth, squarish strokes.

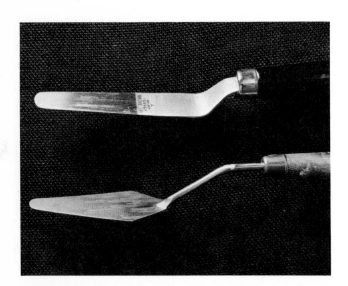

Knives. A palette knife (top) is useful for mixing color on the palette, for scraping color off the palette at the end of a painting session, and for scraping color off the canvas when you're dissatisfied with what you've done and want to make a fresh start. A painting knife (bottom) has a very thin, flexible blade that's specially designed for spreading color on the canvas.

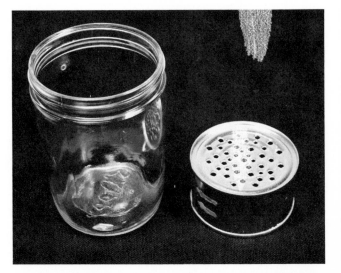

Brush Washer. To clean your brush as you paint, you rinse it in turpentine or mineral spirits (called white spirit in Britain). To create a convenient brush washer, save an empty food tin after you've removed the top; turn the tin over so the bottom faces up; then punch holes in the bottom with a pointed metal tool. Drop the tin into a wide-mouthed jar—with the perforated bottom of the tin facing up. Then fill the jar with solvent. When you rinse your brush, the discarded paint will sink through the holes to the bottom of the jar, and the solvent above the tin will remain fairly clean.

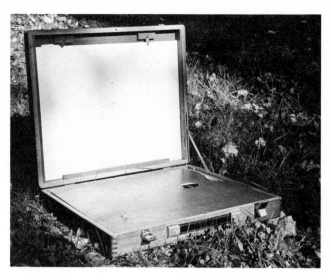

Easel. For working indoors, a wooden studio easel is convenient. Your canvas board, stretched canvas, or gesso panel is held upright by wooden "grippers" that slide up and down to fit the size of the painting. They also adjust to match your own height. A studio easel should be the heaviest and sturdiest you can afford, so it won't wobble when you attack the painting with vigorous strokes.

Paintbox. A paintbox usually contains a wooden palette which you can lift out and hold as you paint. Beneath the palette, the lower half of the box contains compartments for tubes, brushes, knives, bottles of oil and turpentine, and other accessories. The lid of the paintbox often has grooves into which you can slide two or three canvas boards. The open lid will stand upright—with the help of a supporting metal strip which you see at the right—and can serve as an easel when you paint outdoors. You can also buy a lightweight, folding outdoor easel, if you prefer.

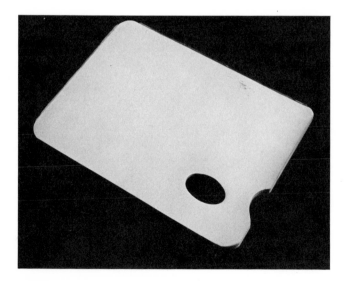

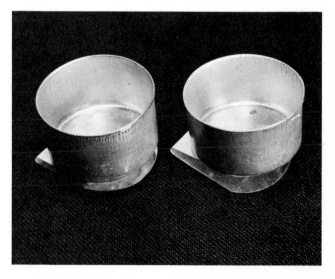

Palette. The wooden palette that comes inside your paintbox is the traditional mixing surface that artists have used for centuries. A convenient alternative is the paper tear-off palette: sheets of oilproof paper that are bound together like a sketchpad. You mix your colors on the top sheet, which you then tear off and discard at the end of the painting day, leaving a fresh sheet for the next painting session. This takes a lot less time than cleaning a wooden palette at the end of the painting day. Many artists also find it easier to mix colors on the white surface of the paper palette than on the brown surface of the wooden palette.

Palette Cups (Dippers). These two metal cups have gripping devices along the bottom so that you can clamp the cups over the edges of your palette. One cup is for turpentine or mineral spirits to thin your paint as you work. (Don't use this cup for rinsing your brush; that's what the brush washer is for.) The other cup is for your painting medium. This can be pure linseed oil; a 50-50 blend of linseed oil and turpentine that you mix yourself; or a painting medium which you buy in the art supply store—usually a blend of linseed oil, turpentine, and a natural resin such as damar, copal, or mastic.

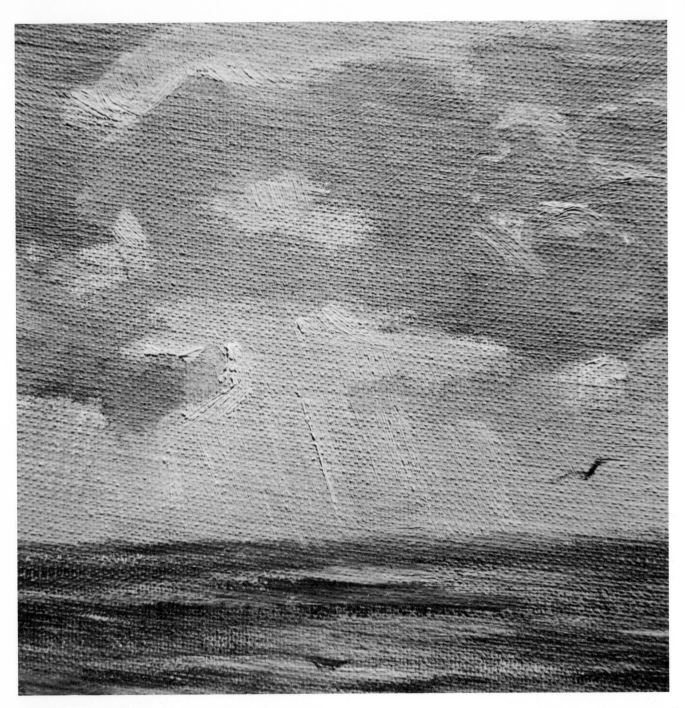

Canvas. The most popular surface for oil painting is cotton or linen canvas. Canvas boards—inexpensive fabric that's covered with white paint and glued to stiff cardboard—are sold in every art supply store. Beginners usually start by painting on canvas boards and then switch to stretched canvas later on. You'll find instructions for stretching your own canvas—which means nailing the fabric to a rectangular wooden framework—later in this book. The weave of the canvas softens your brushstrokes and makes it easy to blend the paint, as you can see in the soft forms of these clouds. The texture of the canvas generally shows through unless you apply the paint very thickly.

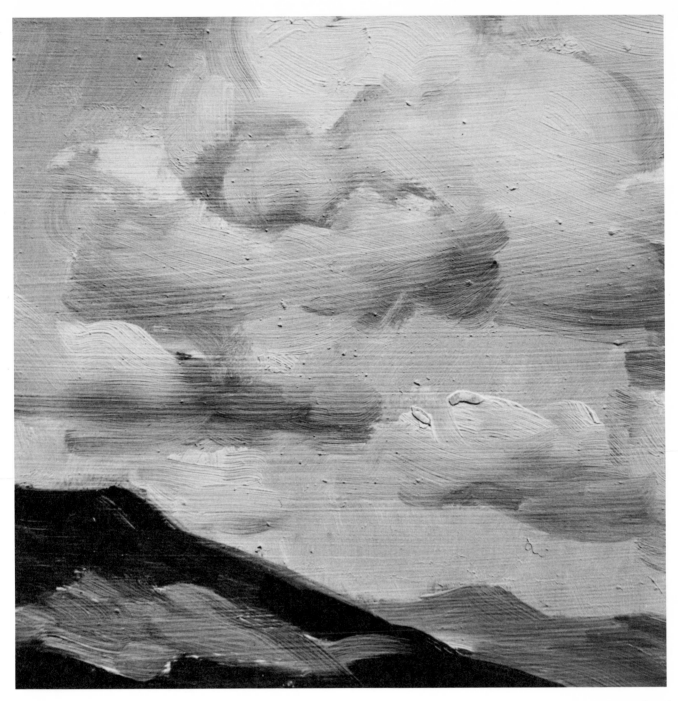

Panel. Some painters prefer to work on the smoother surface of a panel. Today this is usually a sheet of hardboard that's the modern replacement for the wood panels used by the old masters. Like canvas boards and stretched canvas, the panel is coated by the manufacturer with a layer of white oil paint or white gesso. It's easy and inexpensive to prepare your own panels. Most art supply stores stock acrylic gesso, a thick, white paint which you brush onto the hardboard with a nylon housepainter's brush. As it comes out of the jar or the can, the gesso is thick. For a smooth painting surface, thin the gesso with water to a milky consistency and then apply several coats. If you like a rougher painting surface, apply the gesso undiluted or add just a little water; your nylon brush will leave delicate grooves in the gesso as you see here. Even when the gesso has a slight texture, the brush glides more smoothly over a panel than over canvas. Thus, brushwork on a panel has a smoother, more fluid look, as you can see in these clouds.

Step 1. To try out your bristle brushes, find some roughly textured subject like this tree. For the first sketchy lines on the canvas, thin your tube color with lots of turpentine and work with the tip of the brush. Keep the paint as thin as watercolor so that the brush sweeps quickly over the canvas—you can wipe off the strokes with a rag if your want to make any changes. Don't be too careful with these first strokes; most of them will be obliterated by the heavier strokes that come next.

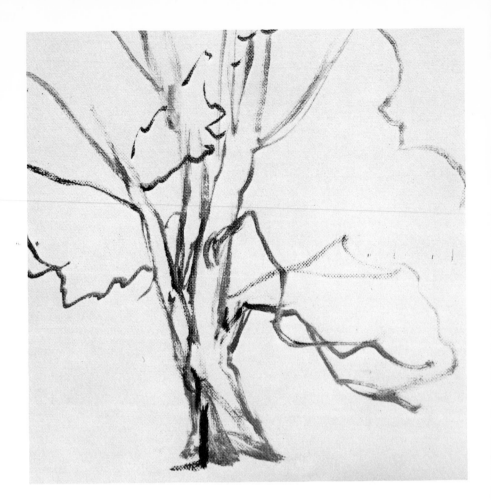

Step 2. Now, working with slightly thicker color—add some linseed oil along with the turpentine—start to brush in the clusters of leaves with broad, free strokes. Notice that many of the strokes in Step 1 have already disappeared under the leaves. Working with the tip of the brush, you can add some darks for the shadows on the trunks. Don't worry about details at this early stage. The idea is to cover the canvas with broad masses of color.

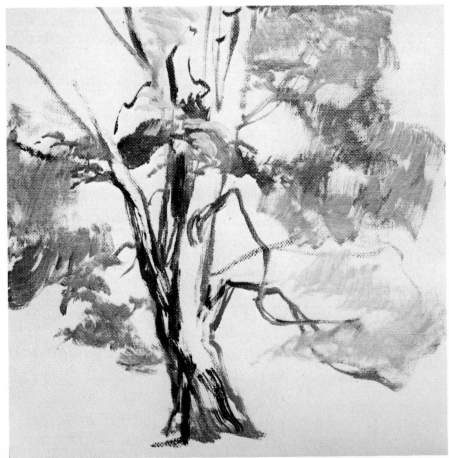

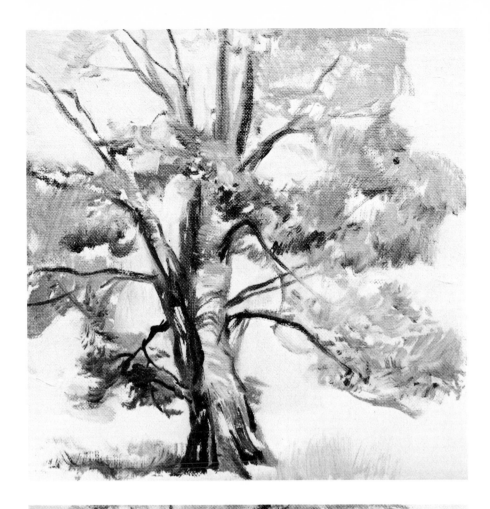

Step 3. By the time you're finished with Step 2, all the clusters of leaves should be covered with rough strokes of color. These are what painters call the middletones—tones that are darker than the lightest parts of the picture, but lighter than the darkest parts. When you have enough middletones on the canvas, you can start to add some darks: the shadows under the clusters of leaves; some more shadows on the trunk and branches; and the shadow cast by the trunk on the grass to your left. Now you're working with the tip of the brush and the strokes are smaller. But don't make your strokes too precise. Try to work with free movements.

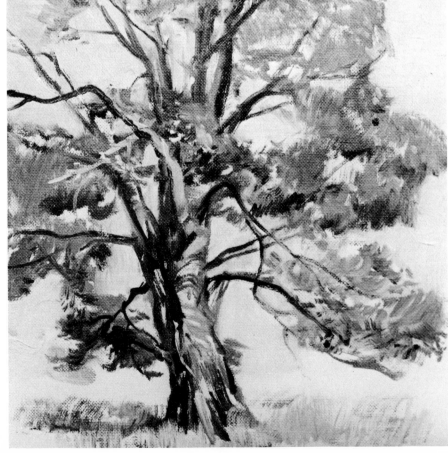

Step 4. Save the brightest touches of light and the details for the very end. Use the tip of the brush to indicate the sunstruck branches and leaves. You can also use the tip of the brush to add darks to the branches—and to add some more branches. Just use the tip to suggest a few leaves. Now you have some idea of the different kinds of strokes you can make with bristle brushes: broad, scrubby strokes for the clusters of foliage; linear, rhythmic strokes for the branches; and mere touches for a few leaves.

Step 1. To learn what your softhair brushes can do, find some subject—like these birches—that lends itself to smooth, linear brushwork. Once again, start out by thinning your tube color with plenty of turpentine so that you can draw the main lines of the composition with the tip of the brush. These trunks are drawn with the tip of a round sable. In fact, this whole demonstration is done with sables, but it's worth noting that exactly the same job could be done with white nylon brushes, which are a lot less expensive!

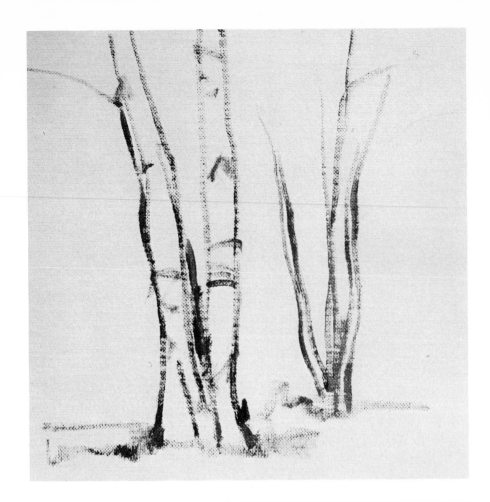

Step 2. In the early stages of a painting, the most important thing is to cover the canvas with broad strokes of wet color. The sky is painted with horizontal and vertical strokes made by a flat, softhair brush, leaving bare canvas for the trunks. The darks at the bottoms of the trunks and along the ground are painted with a round, softhair brush. Note that the sky is painted right over the smaller tree, which is almost obliterated. This is no problem; the tree will be repainted over the sky. You can see the marks of the brush in the sky, but they're much smoother and less distinct than the strokes made by the bristle brush in the preceding demonstration.

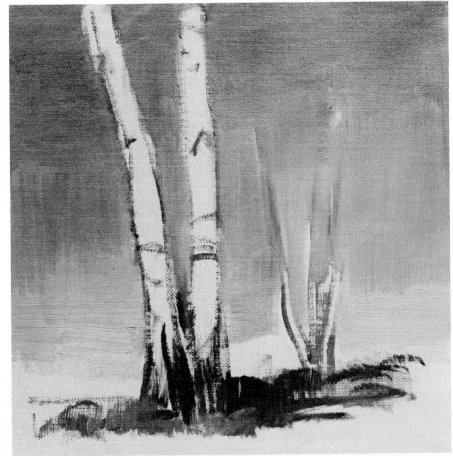

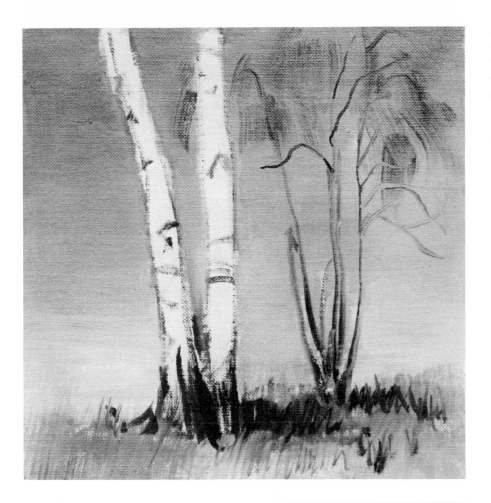

Step 3. Here's where you can see the unique character of softhair brushwork. The sky is blended with the overlapping, horizontal strokes of a flat, softhair brush, producing a lovely gradation from dark to light and almost eliminating the marks of the brush. Then the tip of a round, softhair brush re-establishes the slender trunks of the smaller tree and indicates the texture of the grass. For such smooth brushwork, you need fluid paint that contains a lot of medium.

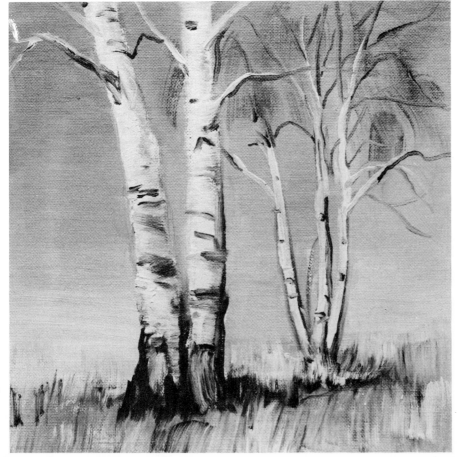

Step 4. The trunks are completed with strokes that are just a bit thicker than the sky and grass, but still contain enough medium to make the paint flow smoothly. The tip of a round, softhair brush adds the dark details in the bark and also adds some more blades of grass. The wispy foliage is painted with a flat, softhair brush, carrying just a bit of color so you can see the tracks left by the hairs of the brush.

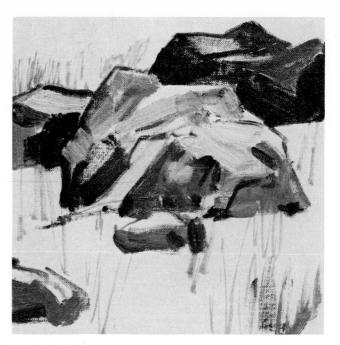

Step 1. Now try combining bristle and softhair brushes to see how many different kinds of strokes you can produce. Try to find some subject that combines big, rough forms and soft, delicate forms, such as these rocks and weeds. Once again, begin by brushing in the main forms with fluid color, thinned with lots of turpentine. A round softhair brush is usually best for this job.

Step 2. It's always best to begin by covering the broadest areas of the picture with big strokes. The rocks are quickly covered with flat strokes made by a big bristle brush. The stiff bristles leave distinct grooves in the paint, accentuating the rough character of the rocks. Such thick strokes contain only a little medium—or none at all—so the paint is a heavy paste.

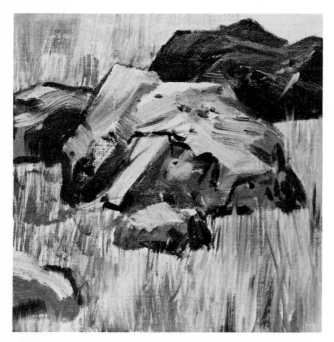

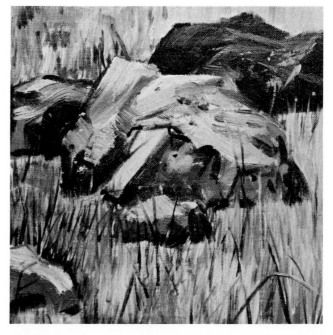

Step 3. Now the round softhair brush comes into play. The paint is thinned with medium to a more fluid consistency. Then the rocks are surrounded with thin, fluid strokes for the grass. Some strokes are dark, while others are light, and the softhair brush easily blends them together. The bristle brush returns to complete the rocks with thick strokes.

Step 4. By the end of Step 3, the entire canvas is covered with broad masses of color, with very little attention to detail. The details are saved for the final step, when the tip of the round softhair brush adds more blades of grass and weeds, a few lighter flecks for wildflowers, and a crack in the rock at the lower left.

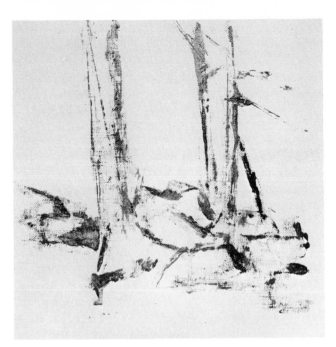

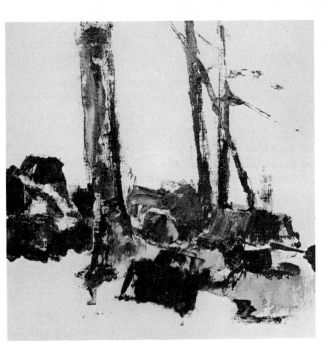

Step 1. Pick up some thick color on the underside of a painting knife. To make the slender lines of the trunks, just touch the side of the knife to the canvas and pull the blade downward, as if you're slicing bread. For thicker lines, such as those on the rocks or at the bases of the trees, press the side of the blade against the canvas and pull slightly sideways to spread the paint.

Step 2. The rocks are painted with broad, squarish strokes, made by the underside of the blade. For the slender trunks at the right, pick up color under the tip of the blade and use it like a brush. The broader trunk is painted partly with the tip and partly with the underside of the knife, not carrying too much paint, so patches of canvas show through.

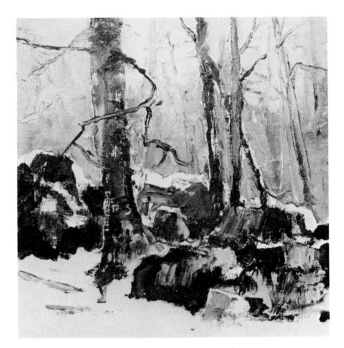

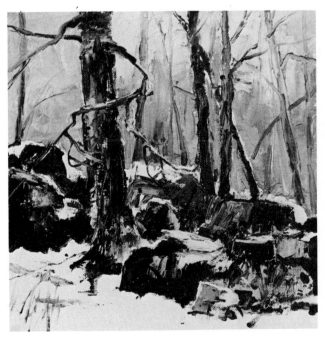

Step 3. The pale tones of the misty woods behind the trees are painted with broad strokes of the underside of the blade. More trunks are added with the tip of the blade. The curving branches on the thicker trunk are painted with curving strokes of the tip. More squarish strokes are added to the rocks in the lower right.

Step 4. On the rocks and the big trunk, the knife blends the lights and darks and roughens the smooth knifestrokes. Bristle brushstrokes are carried right over the knifestrokes to strengthen the trunks and the branches. More branches are added by the brush—a job which is too precise for the knife. Don't overdo the brushwork. Use the brush selectively and then stop.

Buying Brushes. There are three rules for buying brushes. First, buy the best you can afford—even if you can afford only a few. Second, buy big brushes, not little ones; big brushes encourage you to work in bold strokes. Third, buy brushes in pairs, roughly the same size. For example, if you're painting a sky, you can probably use one big brush for the patches of blue and the gray shadows on the clouds, but you'll want another brush, unsullied by blue or gray, to paint the white areas of the clouds.

Recommended Brushes. Begin with a couple of really big bristle brushes, around 1″ (25 mm) wide for painting your largest color areas. You might want to try two different shapes: one can be a flat, while the other might be a filbert. And one might be just a bit smaller than the other. The numbering systems of manufacturers vary, but you'll probably come reasonably close if you buy a number 12 and a number 11. Then you'll need two or three bristle brushes about half this size, numbers 7 and 8 in the catalogs of most brush manufacturers. Again, try a flat, a filbert, and perhaps a bright. For painting smoother passages, details, and lines, three softhair brushes are useful: one that's about 1/2″ (13 mm) wide; one that's about half this wide; and a pointed, round brush that's about 1/8″ or 3/16″ (3-5 mm) thick at the widest point.

Knives. For mixing colors on the palette and for scraping a wet canvas when you want to make a correction, a palette knife is essential. Many oil painters prefer to mix colors with a knife. If you'd like to *paint* with a knife, don't use the palette knife. Instead, buy a painting knife, with a short, flexible, diamond-shaped blade.

Painting Surfaces. When you're starting to paint in oil, you can buy inexpensive canvas boards at any art supply store. These are made of canvas coated with white paint and glued to sturdy cardboard in standard sizes that will fit into your paintbox. Later, you can buy stretched canvas—sheets of canvas precoated with white paint and nailed to a rectangular frame made of wooden stretcher bars. You can save money by stretching your own canvas. You buy the stretcher bars and canvas and then assemble them yourself. If you like to paint on a smooth surface, buy sheets of hardboard and coat them with acrylic gesso, a thick, white paint that you buy in cans or jars and then thin with water.

Easel. An easel is helpful, but not essential. It's just a wooden framework with two "grippers" that hold the canvas upright while you paint. The "grippers" slide up and down to fit larger or smaller paintings—and to match your height. If you'd rather not invest in an easel, there's nothing wrong with hammering a few nails partway into the wall and resting your painting on them; if the heads of the nails overlap the edges of the painting, they'll hold it securely. Most paintboxes have lids with grooves to hold canvas boards. When you flip the lid upright, the lid becomes your easel.

Paintbox. To store your painting equipment and to carry your gear outdoors, a wooden paintbox is a great convenience. The box has compartments for brushes, knives, tubes, small bottles of oil and turpentine, and other accessories. It usually holds a palette—plus some canvas boards inside the lid.

Palette. A wooden paintbox often comes with a wooden palette. Rub the palette with several coats of linseed oil to make the surface smooth, shiny, and nonabsorbent. When the oil is dry, the palette won't soak up your tube colors, and the surface will be easy to clean at the end of the painting day. Even more convenient is a paper palette. This looks like a sketchpad, but the pages are nonabsorbent paper. At the beginning of the painting day, you squeeze out your colors on the top sheet. When you're finished, you just tear off and discard the top sheet. Paper palettes come in standard sizes that fit into paintboxes.

Odds and Ends. To hold your turpentine and your painting medium—which might be plain linseed oil or one of the mixtures you read about earlier—buy two metal palette cups (or "dippers"). To sketch the composition on your canvas before you start to paint, buy a few sticks of natural charcoal—not charcoal pencils or compressed charcoal. Keep a clean rag handy to dust off the charcoal and make the lines paler before you start to paint. Some smooth, absorbent, lint-free rags are good for wiping mistakes off your painting surface. Paper towels or a stack of old newspapers (a lot cheaper than paper towels) are essential for wiping your brush when you've rinsed it in turpentine. For stretching your own canvas, buy a hammer (preferably with a magnetic head), some nails or carpet tacks about 3/8″ (9-10 mm) long, scissors, and a ruler.

Work Layout. Before you start to paint, lay out your equipment in a consistent way so that everything is always in its place when you reach for it. If you're right-handed, place the palette on a tabletop to your right, along with a jar of turpentine, your rags and newspapers or paper towels, and a clean jar in which you store your brushes, hair end up. Establish a fixed location for each color on your palette. One good way is to place your *cool* colors (black, blue, green) along one edge and the *warm* colors (yellow, orange, red, brown) along another edge. Put a big dab of white in one corner, where it won't be contaminated.

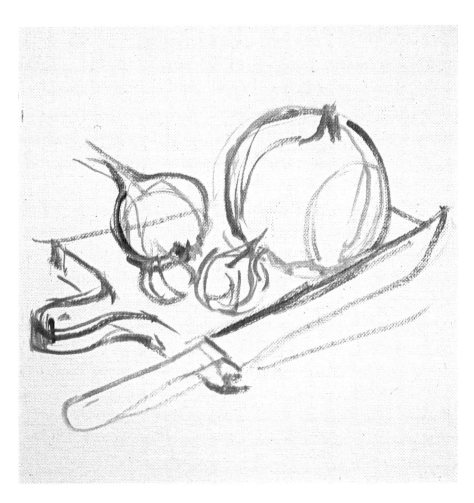

Step 1. When you're learning how to handle oil paint, it's best to begin by painting a few simple, familiar household objects such as these vegetables and kitchen utensils. Just group them casually on a tabletop and go to work. Sketch the forms on the canvas with a few charcoal lines. Use a clean rag to dust off most of the charcoal, leaving the lines very faint. Then reinforce the lines with the tip of a round softhair brush dipped in some quiet color such as burnt umber and diluted with plenty of turpentine.

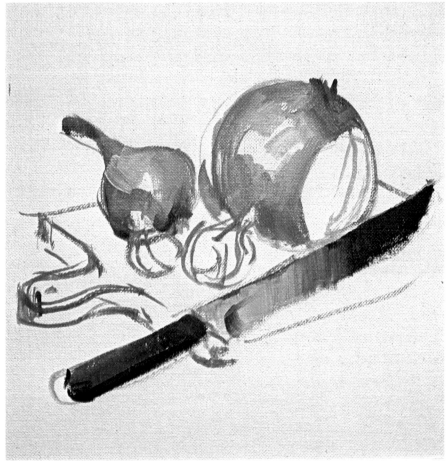

Step 2. The next step is to cover the most important shapes in the picture with broad strokes of color. Use your biggest bristle brushes and don't worry about details. In the early stages, the paint shouldn't be too thick, so add enough medium to give you a creamy consistency. The big onion is painted with cadmium yellow, ultramarine blue, and burnt sienna. The smaller onion is burnt sienna, yellow ochre, and white with some ultramarine blue added in the darks. The darks of the knife are also burnt sienna and ultramarine blue, with the yellow onion mixtures reflected in the lighter part of the blade.

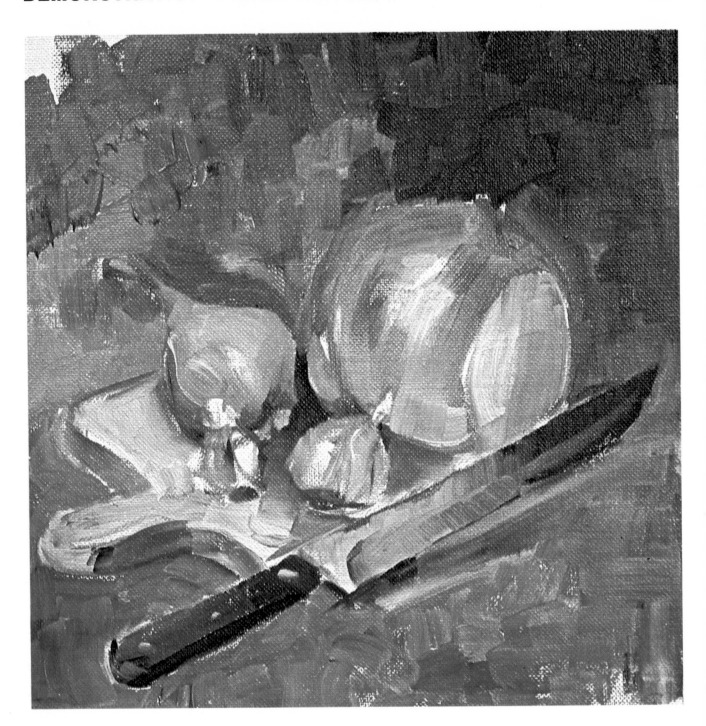

Step 3. Having covered the main shapes with color, your next goal is to cover the entire painting surface. Once again, work with your biggest bristle brushes and use bold, free strokes, paying no attention to details. Don't worry if the painting looks rough and perhaps a bit sloppy; you'll fix that in the final stage. Right now just think about broad areas of color. The dark tone above and behind the onions is a mixture of burnt umber, ultramarine blue, yellow ochre, and white. You can see the broad, squarish strokes of the big bristle brush—there's no attempt to blend them or smooth them out. This same mixture is carried down over the tabletop, switching from burnt umber to burnt sienna, then adding more yellow ochre and white. The rounded forms of the two onions are shaped with strokes of the shadowy background mixture plus more white; notice how the strokes curve around the forms. The cut side of the big onion is painted with vertical strokes of this mixture plus a lot of white. The smaller shapes of the garlic are painted with free, curving strokes of ultramarine blue, burnt umber, and white. The top of the wooden breadboard is painted with this mixture, with less white in the shadow between the onions and the garlic. This same shadow tone appears on the side of the handle of the breadboard, along with some strokes of the yellowish tone used on the big onion. More of this yellowish tone is blended into the knife blade to suggest a reflection in the shiny metal. Part of the knife handle is lightened with a mixture of burnt sienna, yellow ochre, ultramarine blue, and white.

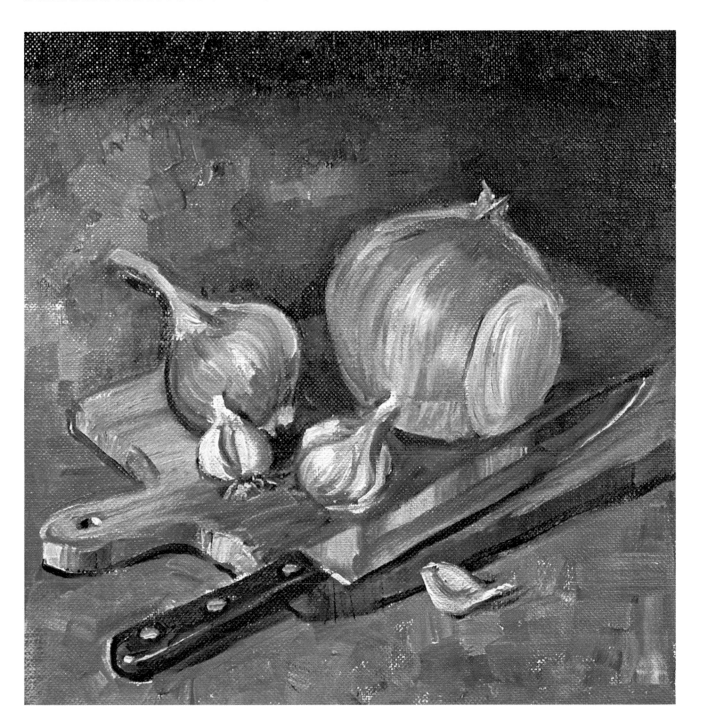

Step 4. By the end of Step 3, the entire picture is covered with wet, juicy color. So far, all the work is done with big bristle brushes. Only in the final stage do smaller bristle brushes and a softhair brush come into play. The tip of a small bristle brush is used to draw curving strokes over the rounded forms of the onions and garlic: mixtures of ultramarine blue, yellow ochre, burnt umber or burnt sienna, and white for the darker strokes; burnt umber, yellow ochre, and lots of white for the paler strokes. The same brush carries the same mixtures across the top of the breadboard to suggest the grain of the wood. The edge of the breadboard is darkened with ultramarine blue, burnt sienna, and a little white. Then the tip of a round softhair brush draws lines of

this same mixture over the garlic and into the knife blade. The softhair brush then draws darker lines of the same mixture (containing less white) along the undersides of the vegetables, breadboard, and knife, to suggest shadows. This same brush adds touches of detail such as the rivets in the knife handle and the hole in the breadboard handle, plus a stroke of pure white toward the tip of the knife blade. A flat softhair brush blends and smoothes the background tone in the upper right area, adding some strokes of ultramarine blue, burnt sienna, and white to suggest the edge of the tabletop disappearing into the darkness. But the blending isn't carried too far—most of the original brushwork remains, still rough and spontaneous.

Step 1. Fruit is another common subject which is easy and delightful to paint. Rather than sketching your preliminary lines in charcoal, you might like to try working directly with a round softhair brush, burnt umber, and plenty of turpentine so that the lines won't be too dark. Then you can reinforce and correct these first lines with a darker mixture containing less turpentine. Here, you can see where the dark lines are drawn right over and around the lighter ones.

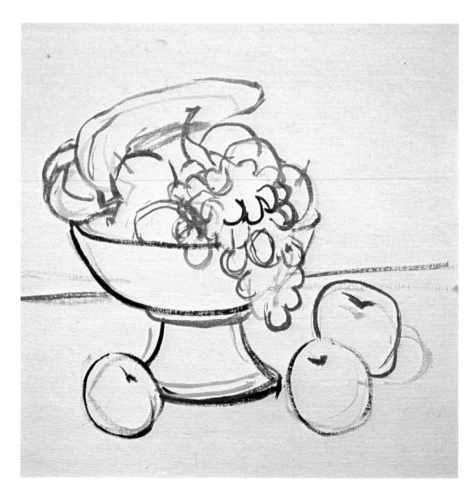

Step 2. Following the same basic method, start out once again by covering some of the important shapes with broad strokes of creamy color diluted with just enough medium to make the paint flow easily. The apples are painted with curving strokes of alizarin crimson, cadmium red, cadmium yellow, and a little white. The oranges in the bowl are quickly covered with cadmium red, cadmium yellow, and white. The bananas and the lemon on the tabletop are painted with cadmium yellow and white, softened with a touch of burnt umber and ultramarine blue.

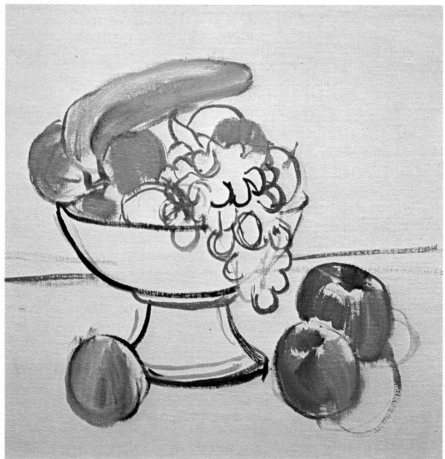

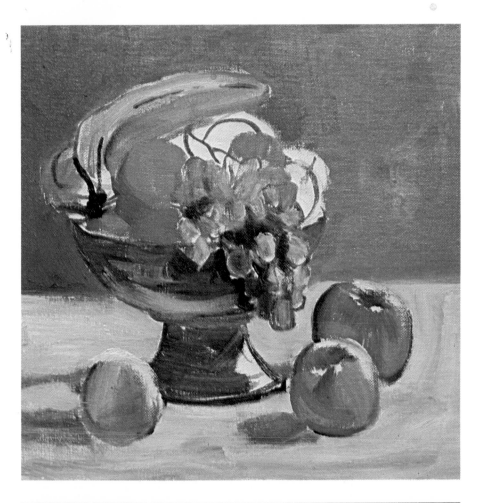

Step 3. At this stage, the goal is still to cover the entire canvas with wet color, working with big bristle brushes and not worrying about detail. The background is covered with a mixture of alizarin crimson, cadmium red, a little ultramarine blue, and white. The tabletop is brushed with horizontal strokes of burnt umber, ultramarine blue, and white—with a darker version of this mixture in the shadows. More of the apple mixture is brushed over the fruit in the bowl. The grapes are covered with dark and light strokes of ultramarine blue, cadmium yellow, burnt sienna, and white. The bowl is painted with curving strokes of ultramarine blue, alizarin crimson, and white.

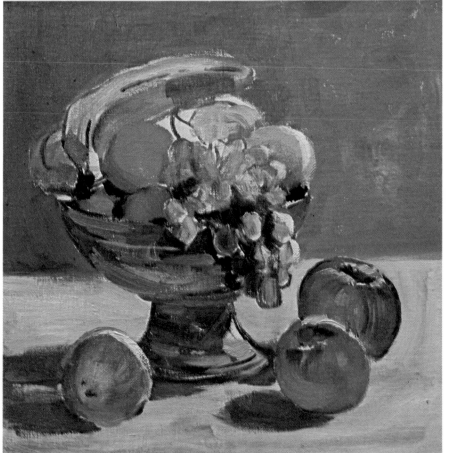

Step 4. Now smaller bristle brushes add some darks and lights to make the forms look more three-dimensional. Some burnt sienna and ultramarine blue are added to the apple mixture for the shadow sides of the apples. Some burnt umber and ultramarine blue darken the lemon on the table top. The shadows on the table are extended with this same mixture. Touches of dark are added among the fruit in the bowl with burnt sienna and ultramarine blue. The bowl is brightened with strokes of cobalt blue and white. And some strokes of almost pure white—with just a hint of cobalt blue—are drawn over the tops of the fruit to make them look shiny.

Step 5. When the canvas is completely covered with wet color, you're ready to start refining the forms. Shadows are added to the bananas with curving strokes of cadmium yellow, burnt umber, ultramarine blue, and white. A bit more white is added to the apple and lemon mixtures to soften the tones of the fruit in the bowl. Light and dark strokes of ultramarine blue, cadmium yellow, and white are drawn around the grapes with the tip of a round brush. The same brush is used to strengthen the shape of the bowl with dark lines of burnt sienna and ultramarine blue.

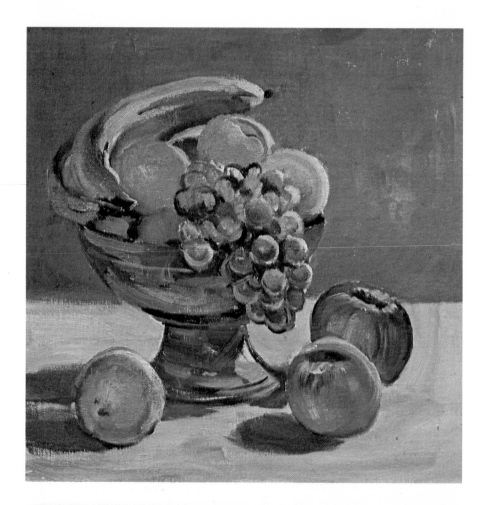

Step 6. The painting is now approaching its final stages, and it's time to begin thinking about details. So far, nearly all the work has been done with flat bristle brushes. Now a small round brush draws dark lines of burnt umber and ultramarine blue to indicate the stems of the grapes and apples, the dark patches on the banana skins, and the shadows among the grapes. This same brush is rinsed in turpentine, wiped on newspaper, and picks up a bit of pure white to suggest flashes of light on the edges of the banana, grapes, apples, and vase.

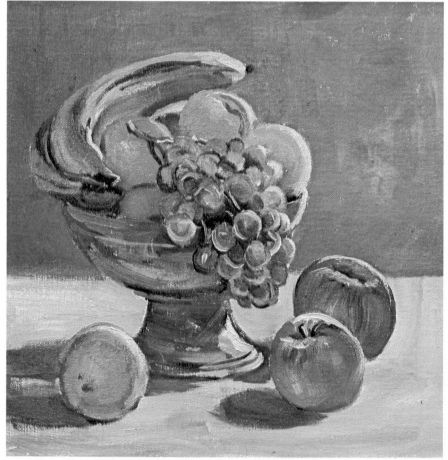

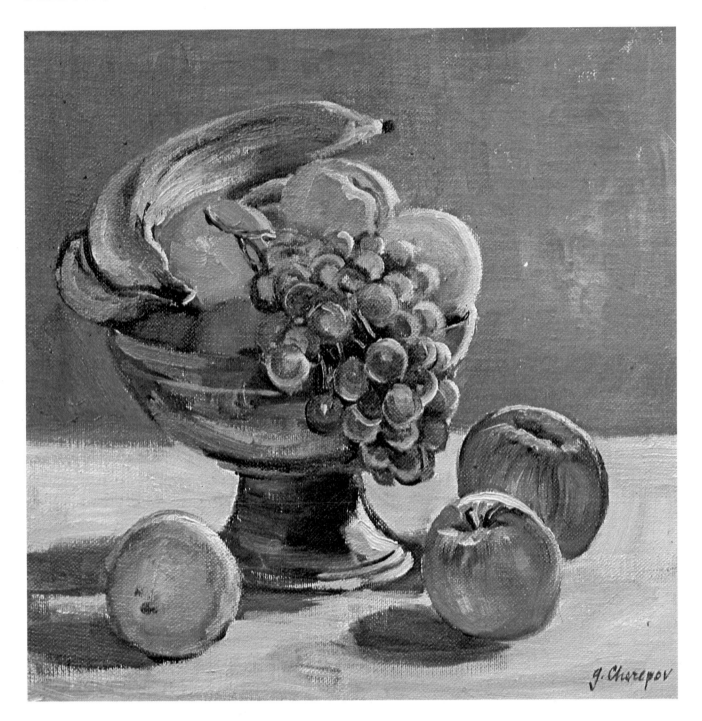

Step 7. You might think that the picture is finished at the end of Step 6—but not quite. There's still room for a few refinements. A small bristle brush adds some cadmium yellow and white to the inside of the banana and blends this bright tone into the shadow. The shadow on the base of the bowl is darkened with burnt umber and ultramarine blue. A small, flat softhair brush blends the lights and shadows on the grapes to make them more luminous—and then the round brush adds some shiny strokes of white slightly tinted with the original greenish mixture. Some of the warm background tones are blended into the light areas of the tablecloth and also into the shadows cast by the fruit and the bowl. Notice that the only touches of really thick paint are saved for these final stages: the bright tone inside the curve of the banana, the flash of light on the base of the bowl, and the lighted top of the nearest apple are painted with thick strokes that literally stand up from the canvas.

Step 1. Flowers are certainly the most popular of all still life subjects. Don't waste too much time arranging them neatly in the vase. Just arrange them casually and go to work on the preliminary drawing on the canvas. Here you can see the first pale lines of the composition, followed by darker lines drawn right over them. Notice that most of the flowers are drawn as simple, round forms, with only a few strokes to indicate petals. After all, these strokes will soon be covered with opaque color—which already begins to appear in rough strokes at the top of the bouquet.

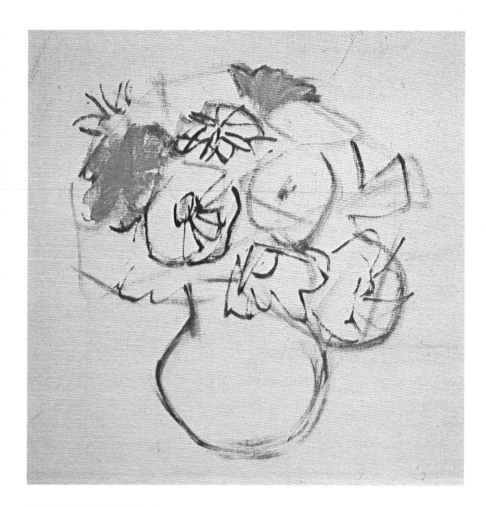

Step 2. Now begin to scrub in the colors of the flowers with your biggest bristle brushes. Just paint them as patches of bright color and don't worry about their precise forms. The red flowers are cadmium red, alizarin crimson, and a bit of ultramarine blue in the darks. The pink flowers are the same mixture, plus a lot of white. The orange flower is cadmium red and cadmium yellow, plus some white. The yellow flower at the top is cadmium yellow, white, and a touch of ultramarine blue. The darkest flower at the right is ultramarine blue, alizarin crimson, and white.

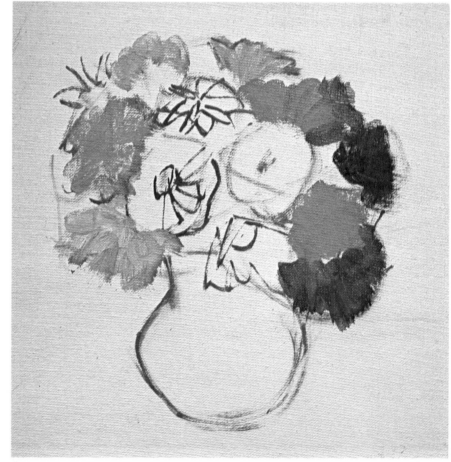

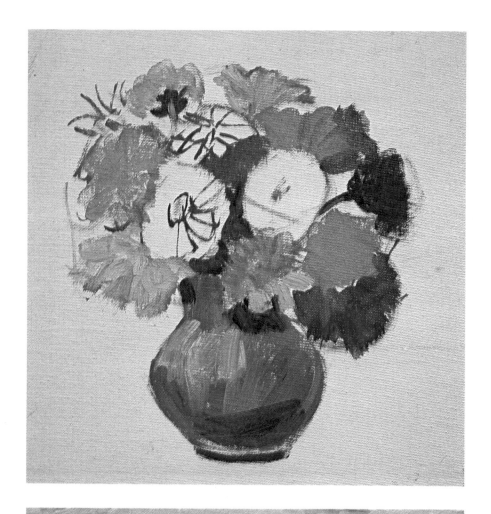

Step 3. The bristle brush now blocks in the shape of the vase with phthalocyanine blue, burnt sienna, and white. The tip of a small bristle brush adds a few stems and some other notes of green among the flowers with viridian and burnt sienna. Another yellow flower is painted with cadmium yellow and white, with a little burnt umber in the shadow area. You still can't see any petals, but the brushstrokes seem to follow the direction of the petals, and those rough dabs of color begin to look like flowers.

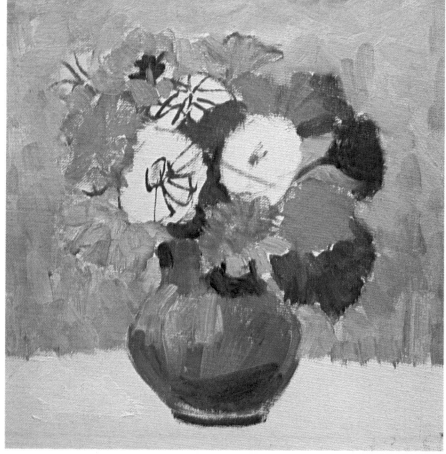

Step 4. The wall behind the flowers is painted with short, quick strokes of ultramarine blue, cadmium red, yellow ochre, and white, with a bit more yellow ochre in the upper left area. Don't worry if the background tone works its way over the edge of the flowers, which will be sharpened up in later stages.

Step 5. The tablecloth is painted with cadmium yellow, white, and a bit of burnt umber in the shadow, The flat shape of an orange flower is added to the bouquet with cadmium red, cadmium yellow, and some white. At this point, the entire canvas is covered with rough strokes of color, leaving bare canvas for just two white flowers. Not a single flower is painted in precise detail, and the entire job is done with bristle brushes.

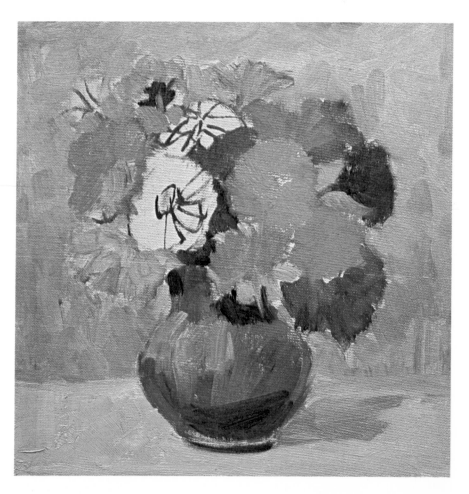

Step 6. Now the smaller bristle brushes and the round softhair brush go into action. The larger white flower is painted with white and yellow ochre in the lights, ultramarine blue, burnt sienna, yellow ochre and white in the shadows. Some burnt sienna and ultramarine blue are stroked across the tabletop to suggest folds in the cloth. The round brush picks up a fluid mixture of burnt sienna and ultramarine blue, then dashes in a few quick, casual lines to suggest the center of the flowers and some petals. The side of the vase is darkened with the original mixture used in Step 3, but which now contains less white.

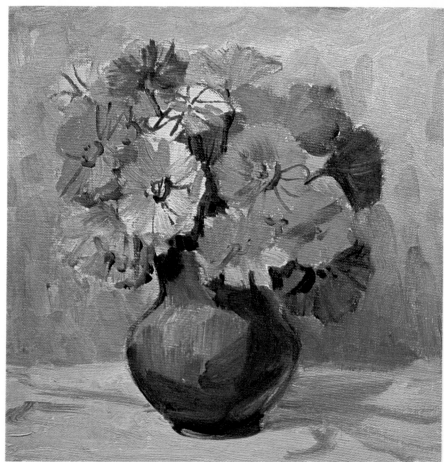

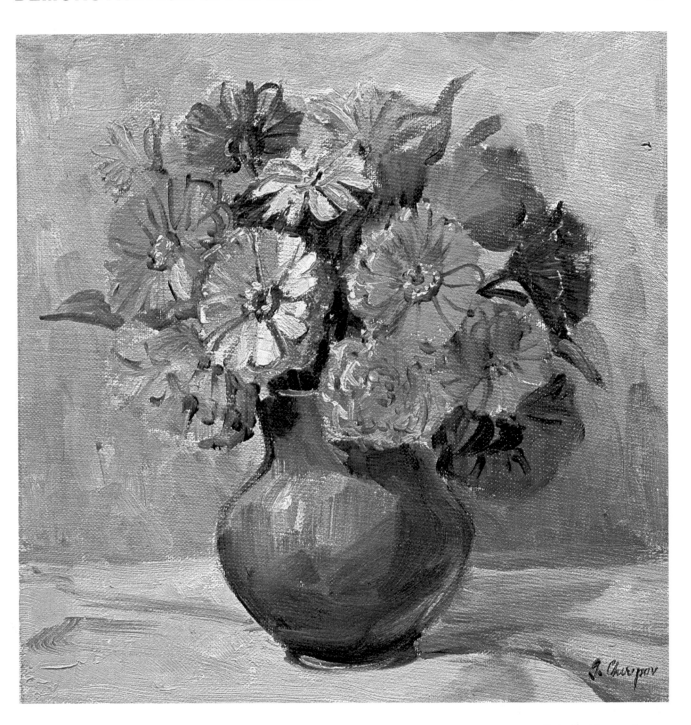

Step 7. The last precise touches are saved for the final stage. The smaller white flower is completed with the round brush, using the same mixtures used for the bigger white flower. The tip of the round brush adds more dark lines to the flowers—but doesn't paint every petal! Only a few petals are picked out in each flower. Then the round brush picks up a bright mixture of white tinted with just a little yellow ochre and adds some quick strokes to the flowers in the center of the bouquet to suggest light flashing on the petals. More leaves and other notes of green are added with viridian, cadmium yellow, and ultramarine blue. The shadow on the table to the right of the vase is darkened with this same mixture. The brushwork is worth studying carefully: the flowers look surprisingly complete, although they're nothing more than scrubby patches of color with a few light and dark lines drawn over them.

Step 1. The hardest still life objects are metal and glass, so don't try these until you've done some easier still lifes of vegetables, fruit, and flowers. Then arrange a few bottles and other kitchen containers on a tabletop and draw them carefully with charcoal or with a round brush. Start out with very pale lines. Draw the shapes as simply as you can, using just straight and curved lines.

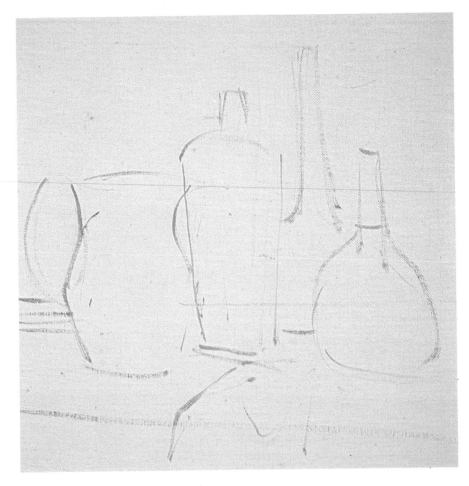

Step 2. When the shapes seem right, go over the lines with darker color, still using plenty of turpentine so that the brush moves freely over the canvas. Don't make the lines *too* precise, since they'll be covered with paint very soon.

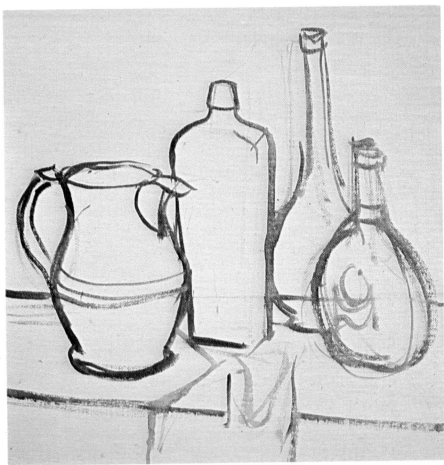

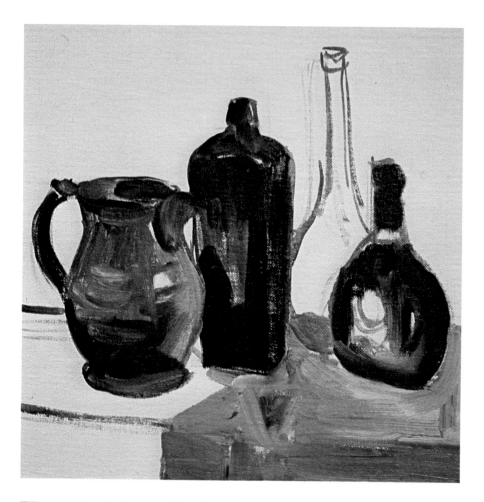

Step 3. Cover the main forms with broad strokes of creamy color. Make your brush follow the directions of the forms: straight strokes for rectangular forms and curving strokes for rounded forms. The pitcher is painted with strokes of burnt umber, ultramarine blue, and white. The bottles are burnt umber, cadmium yellow, ultramarine blue, and white. The cloth on the table is the same mixture with more yellow and white.

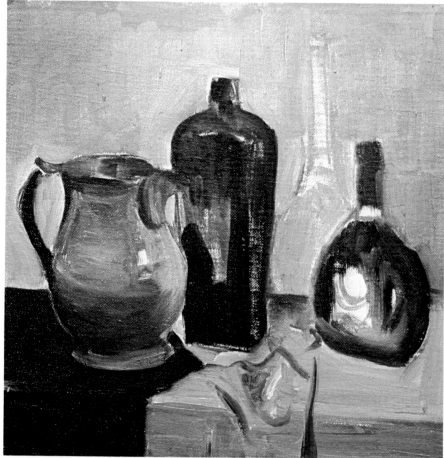

Step 4. The wall is painted with vertical strokes of cadmium yellow, burnt umber, a little ultramarine blue, and lots of white. The bare tabletop is painted with burnt sienna, ultramarine blue, yellow ochre, and white; the folds in the cloth are painted with the same mixture. Notice that the background tone is painted around the pale, ghostly shape of the glass bottle, which will be completed later. More strokes of the original mixture are added to the shadowy underside of the pitcher.

Step 5. With the canvas virtually covered, it's time to sharpen up the edges of the forms. Working with the original mixtures, a small bristle brush carefully retraces the edges of the pitcher to the left and the bottle to the right. A label is added to the face of the bottle, and some dark lines are drawn around the neck. A yellow ribbon is added to the bottle with cadmium yellow, burnt umber, and white.

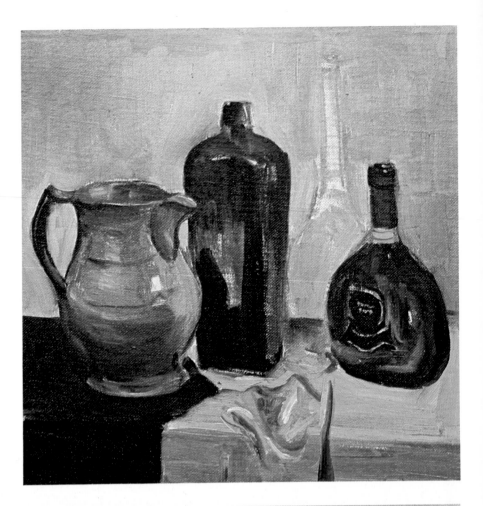

Step 6. The pale, transparent form of the slender bottle is painted with ultramarine blue, alizarin crimson, yellow ochre, and white—with almost pure white in the highlights. This same pale mixture is brushed into the sides of the darker bottles to the right and left of the pale bottle. And this mixture is used to add some lighter notes to the metal pitcher.

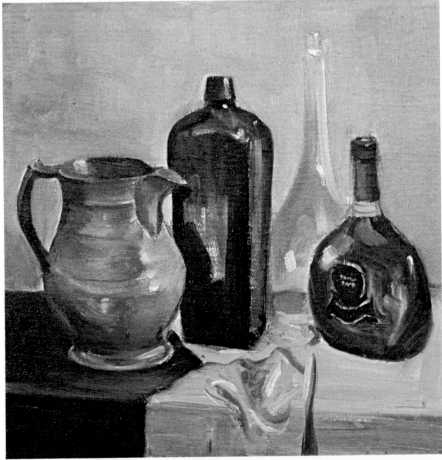

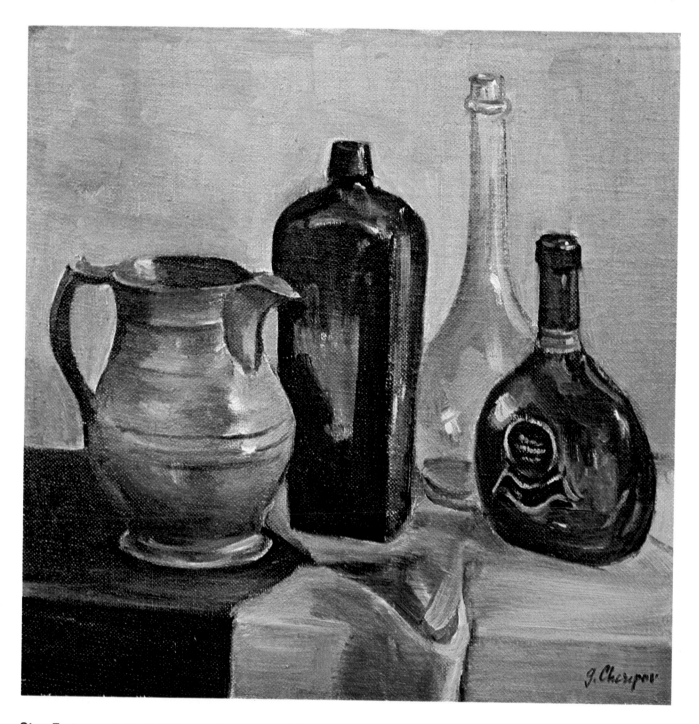

Step 7. As usual, the finishing touches are saved for the final stage. The tip of a round brush draws crisp, dark lines of ultramarine blue and burnt sienna around the edge of the bottle to the right and uses the same mixture to sharpen up the edges of the other dark bottle. This same mixture is drawn around the base of the pitcher and inside the dark opening. Then the brush is rinsed, and the edges of the pale glass bottle are sharpened with thin strokes of the original mixture. Highlights of ultramarine blue and white are added to the dark bottle at the right, while highlights of pure white are added to the other bottles and the pitcher. A final adjustment needs to be made to the central bottle and the cloth. The drapery is darkened with some burnt umber and yellow ochre; the folds are simplified; and a reflection of the drapery color is added to the face of the dark bottle.

Step 1. Having painted several still lifes indoors, the logical next step is to find what might be called an outdoor still life. Try painting some big, solid objects such as a rock formation, perhaps surrounded by wildflowers. In this preliminary drawing, you can see that the pale lines of the rocks are drawn first, then corrected and reinforced by darker lines. These strokes are all burnt umber diluted with plenty of turpentine.

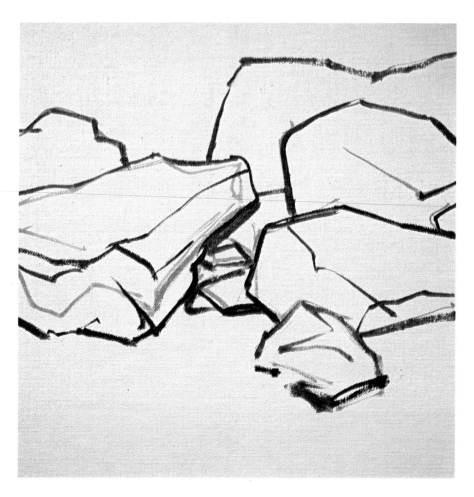

Step 2. The rocks are begun with broad, squarish strokes of a bristle brush to suggest their blocky shapes. The lighter tones are mixtures of ultramarine blue, burnt sienna, yellow ochre, and white. The darker strokes are ultramarine blue and burnt sienna. Each stroke is a slightly different combination of these colors so that some strokes are dominated by blue, others by reddish brown, and still others by yellow.

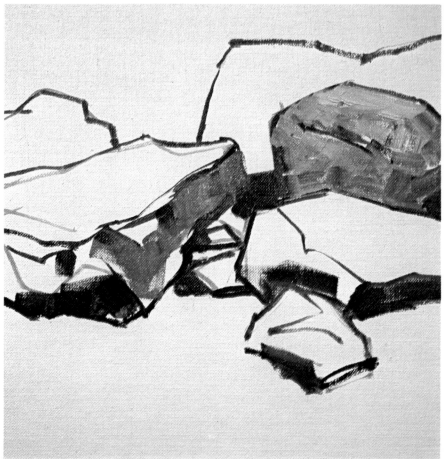

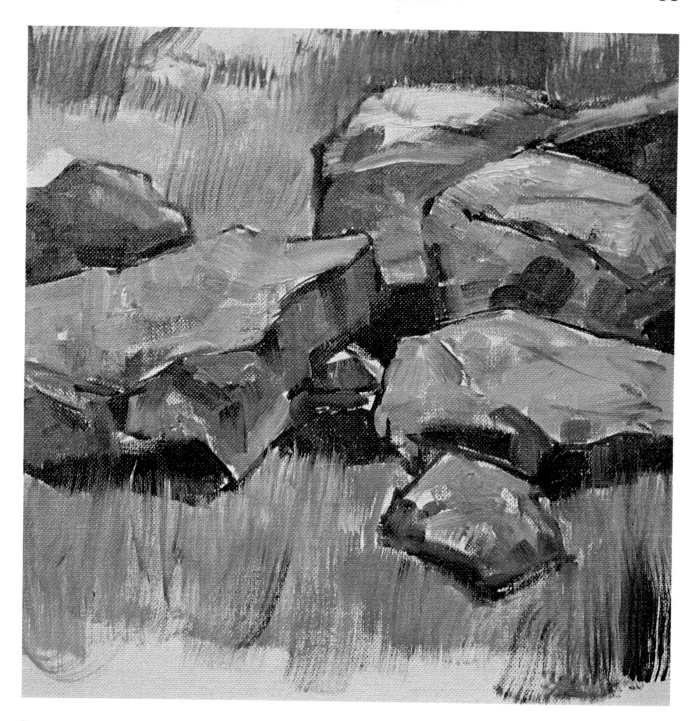

Step 3. The rocks are completely covered with broad strokes of the mixtures introduced in Step 2. The strokes aren't blended, but each stroke stands out with its own texture and color. Notice the stroke of almost pure white that suggests a flash of sunlight on the topmost rock. The meadow above and below the rocks starts out as a broad, very scrubby tone of cadmium yellow, viridian, a little burnt sienna, and a lot of turpentine, simply to cover the canvas. Then the tip of a round brush works over this mixture with rapid strokes of viridian and burnt sienna blended partly into the wet undertone and suggesting weeds and grasses. Notice how these slender strokes move up over the shadowy undersides of the rocks.

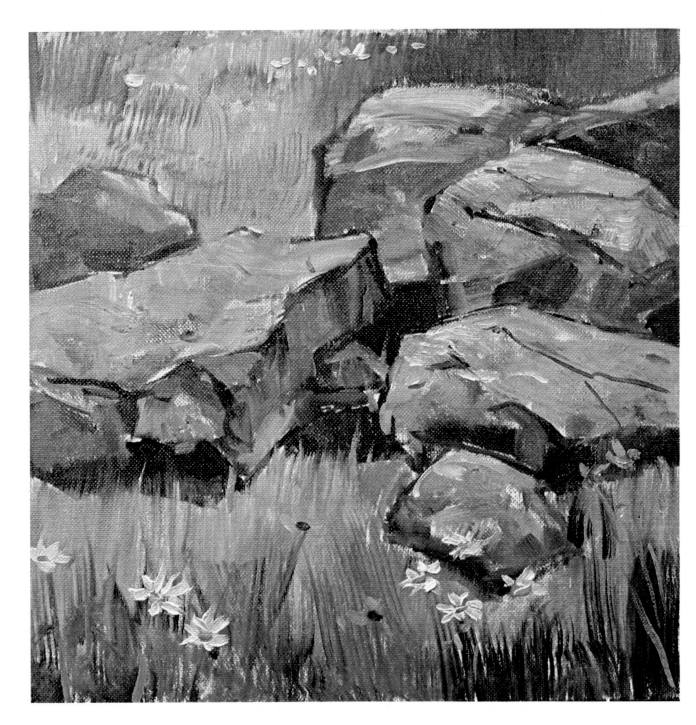

Step 4. The strokes of the meadow are carried to the top and bottom of the canvas with the same round softhair brush. Dark blades of grass are suggested in the left foreground with a mixture of cadmium yellow, viridian, and burnt sienna. Paler strokes of this mixture are carried·upward to the base of the rock where the mixture is now mainly cadmium yellow. Light and dark strokes of this mixture are continued above the rock and over the distant meadow. Then a much darker blend—mainly burnt sienna and viridian—suggests the grasses and weeds in the lower right area. Now a bristle brush picks up a pale version of the original rock mixture of ultramarine blue, burnt sienna, yellow ochre, and lots of white. This blend is carried over the tops of the rocks with rough, thick strokes that emphasize the rocky texture. The tip of the round softhair brush draws some cracks in the rocks with burnt sienna and ultramarine blue diluted to a fluid consistency. This same brush adds some wildflowers with strokes of pure white for the petals and a dab of cadmium yellow and burnt sienna at the center. The orange flowers are cadmium red and cadmium yellow, with burnt umber in the center.

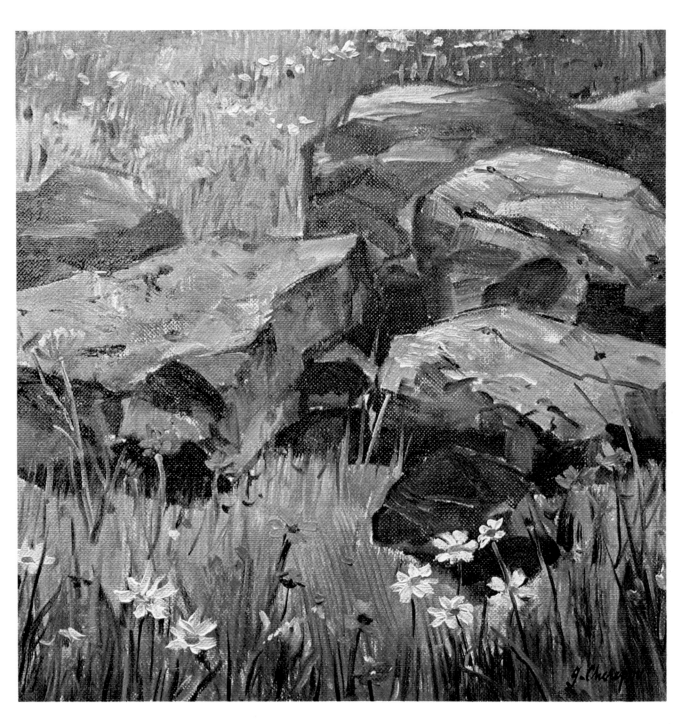

Step 5. The rocks need more contrast between their sunlit tops and shadowy sides. So the sides are darkened with bristle brushstrokes of burnt sienna, ultramarine blue, yellow ochre, and just a little white. Notice that the dark strokes are thin—containing a lot of medium—while the lighter strokes at the tops of the rocks are thicker paint, containing much less medium. The white flower strokes, begun in Step 4, are now carried over the distant meadow at the top of the picture, interspersed with a few touches of the orange mixture. Although the strokes are pure white, they blend slightly with the underlying color; thus, the white becomes cooler or warmer, depending upon the tone underneath. More orange flowers are added in the foreground. Their dark and light stems are the same dark and light mixtures used to paint the grass and weeds. Some scattered purple flowers are a blend of ultramarine blue, alizarin crimson, and white. The picture is completed with crisp dark and light strokes of viridian, burnt sienna, and cadmium yellow—applied with the round brush—to indicate more detail in the foreground.

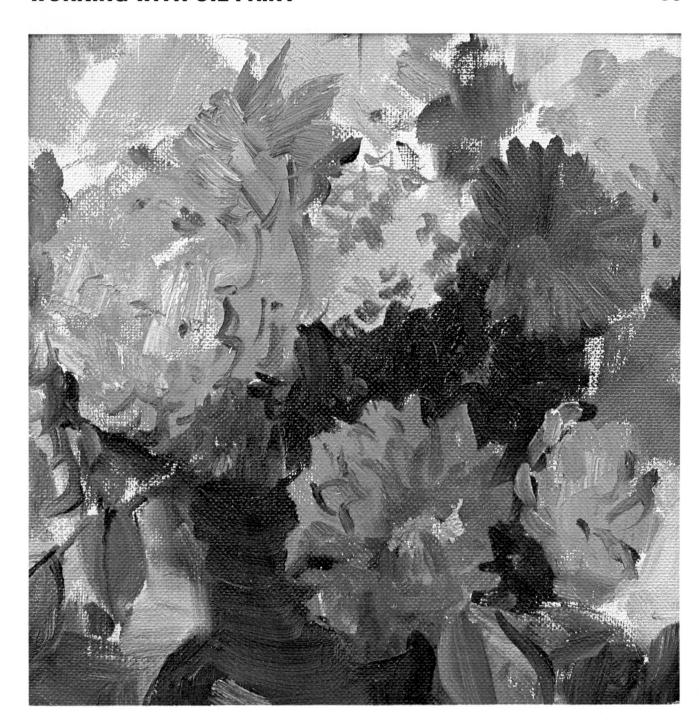

Selective Detail. Now let's look at some lifesize close-ups of several oil paintings to see how the paint is handled. This cluster of flowers—part of a much larger painting—shows you how little detail you need to make a subject look convincing. All the strokes are quick, free, and casual. Each flower is essentially a roughly painted patch of color in which you can see the strokes quite clearly. To make these patches of color look more like flowers, just a few details are added. You can see how a few dark lines suggest petals in the yellow and red flowers at the center of the picture. The strokes follow the direction of the forms: notice how the flower at upper right is painted with radiating strokes that move outward from the center. But you can't see a single petal! This principle of selective detail works just as well when you're painting rocks, trees, or any other subject.

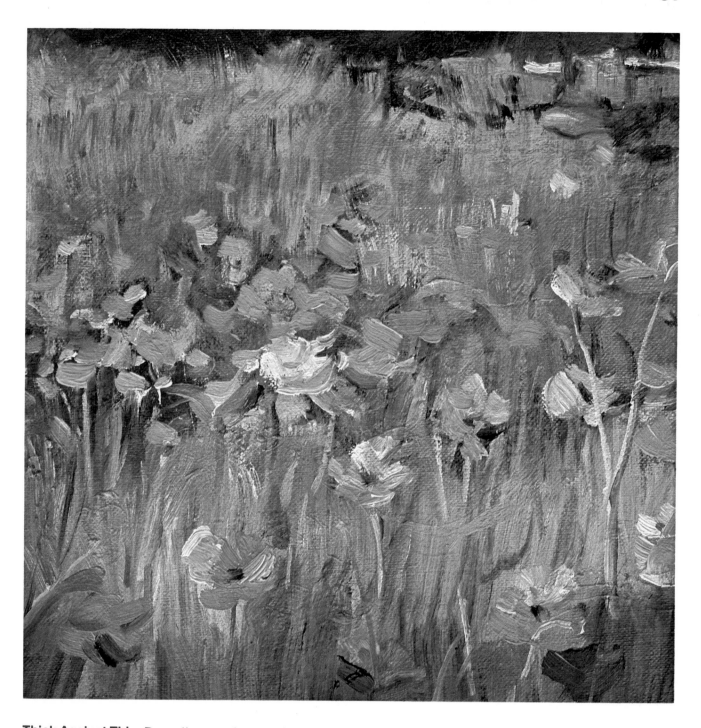

Thick Against Thin. Depending upon how much medium you add to your tube color, oil paint can be as thick or as thin as you like. Some subjects lend themselves to thin color, while others seen to need thick color. And it's often a good idea to play thick color against thin. For example, the grasses in this meadow are first painted in slender strokes of thin color that contains a lot of medium. Then the wildflowers are painted right over the wet strokes of the grasses—but in short strokes of thick color that contains very little medium. The thickness of the wildflowers accentuates the contrast between the flowers and the grass. The flowers seem to jump up above the grass. Notice how the nearest flowers are more thickly painted than the flowers in the distance.

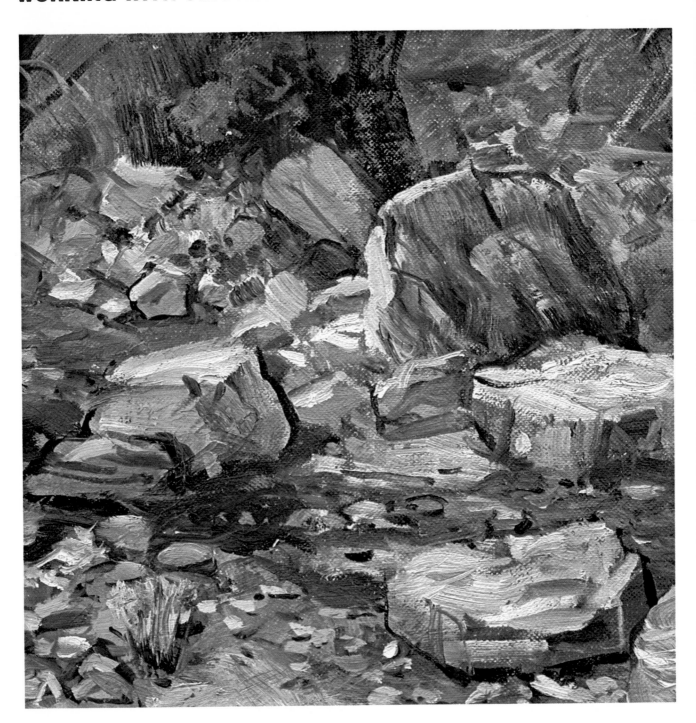

Brushwork Creates Texture. Because oil paint can be thick or thin and brushwork can be rough or smooth—depending upon whether you use bristle or softhair brushes— you can make the texture of the paint match the texture of the subject. For example, if you're painting rocks like these, you can work with thick, pasty paint containing little or no medium. And you can work with stiff bristle brushes— brights are the stiffest—to make your strokes look ragged and irregular. This combination of thick paint and ragged brushwork is ideal for expressing the rough, craggy texture of the rocks. Even the pebbles can be painted with small touches of thick paint, which makes them seem to stick up from the ground.

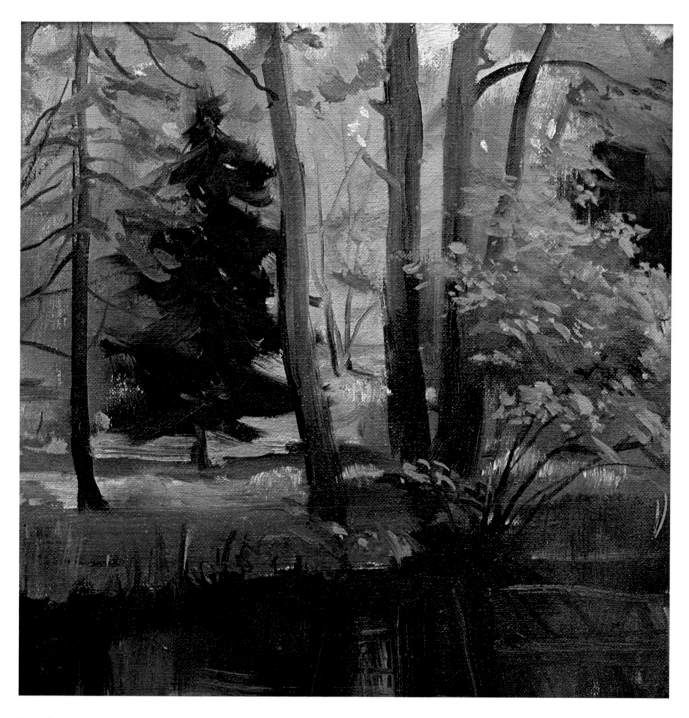

Brushwork Creates Atmosphere. In this close-up of a section of a painting of deep, shadowy woods, you can see how thin, fluid paint creates a totally different effect from the rocks on the preceding page. The paint is diluted with a lot of medium to produce a soft, fluid consistency. And softhair brushes are used to make fluent strokes that melt together and have very little texture. This combination of soft brushwork and fluid color creates a magical, shadowy atmosphere. Notice how the reflections of the trees seem to melt away into the dark water. In the same way, the left side of the evergreen blurs softly into the paler tone of the woods beyond.

Step 1. Summer is a fine time to go outdoors and paint your first landscape. It's usually best to make your first brush lines in some color that will harmonize with the colors of the finished picture. The preliminary brush drawing is cobalt blue plus plenty of turpentine. Then the distant hills are painted with mixtures of cobalt blue, alizarin crimson, yellow ochre, and white. You can see that some strokes contain more blue, others contain more crimson, and still others contain a lot of white.

Step 2. The big, dark hill is painted with the same blend of colors—although you can see that the proportions of blue, red, yellow, and white vary from stroke to stroke. The darker strokes contain more blue or red. The light patch is mostly yellow ochre and white. The dark mass at the base of the hill is mostly blue and red, with almost no white. Everything is done with bristle brushes. The strokes are all broad and rough.

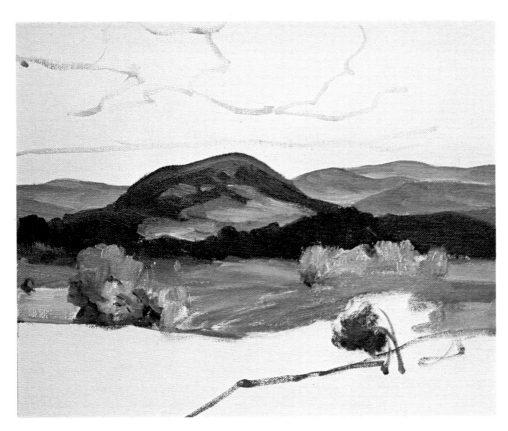

Step 3. The sunny colors of the meadow are painted with essentially the same combination of blue, red, yellow, and white—but cadmium yellow is substituted for the more muted yellow ochre, while the delicate cobalt blue is replaced by the deeper ultramarine. The combination of cadmium yellow and ultramarine blue produces these lovely yellow-greens, warmed here and there by a stroke of crimson or cooled by a stroke of blue. Notice that the meadow is painted with smooth, horizontal strokes, while the trees are executed with short, scrubby, vertical and diagonal strokes that suggest clusters of foliage.

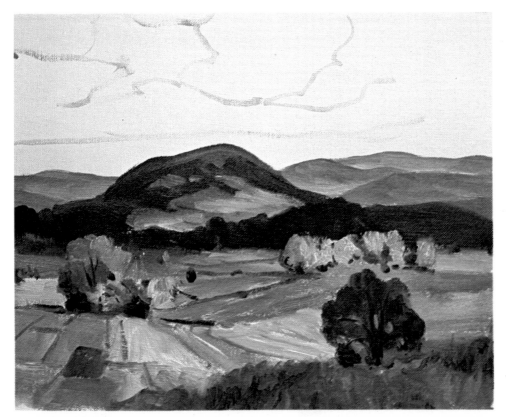

Step 4. More strokes of the meadow mixtures are carried into the foreground, which is even sunnier and contains more cadmium yellow and white in the brightest patches. The meadow is divided into the geometric forms of cultivated fields, each with its own color—containing more blue, red, or yellow. The dark tree and the patch of shadow in the right foreground are a blend of cadmium yellow, ultramarine blue, and burnt sienna instead of alizarin crimson. This same mixture is used for the shadows on the more distant trees. The tip of a round brush picks up this mixture and draws the lines of the fields as well as the trunks and branches of the trees.

Step 5. Until now, no work has been done on the sky. Here you can see that the sky tones are brushed around the shapes of the clouds, which remain bare canvas. The mixtures are the same ones used for the hills: cobalt blue, alizarin crimson, yellow ochre, and white. The lower sky is mostly yellow ochre and white, with just a hint of blue and red. The upper sky is dominated by blue with a good deal of white but just a hint of red and yellow in the mixture. At the midpoint of the sky, these two tones are softly blended together by a flat softhair brush.

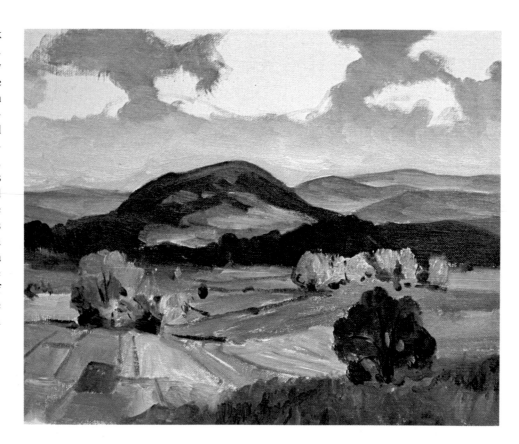

Step 6. The shadowy undersides of the clouds are also painted with a flat softhair brush. The colors are the same as the sky, but with more alizarin crimson and a lot of white. For the sunlit edges of the clouds, the bristle brush comes into play again, carrying a thick blend of white with just a speck of sky tone. You can see that the sunny edges are thicker and more ragged than the soft, smooth shadow strokes. A small, flat softhair brush picks up the dark sky tone and adds some dark notes to the undersides of the clouds—then adds some wisps of dark clouds in the lower sky at the left.

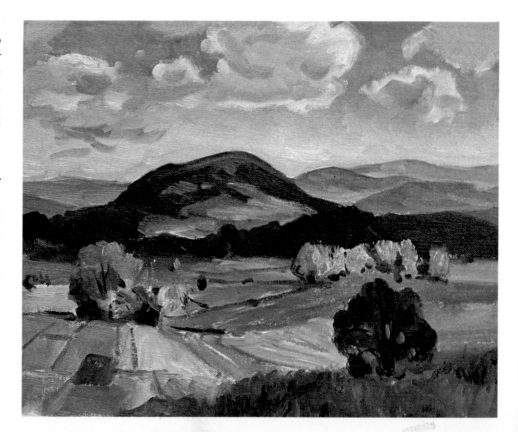

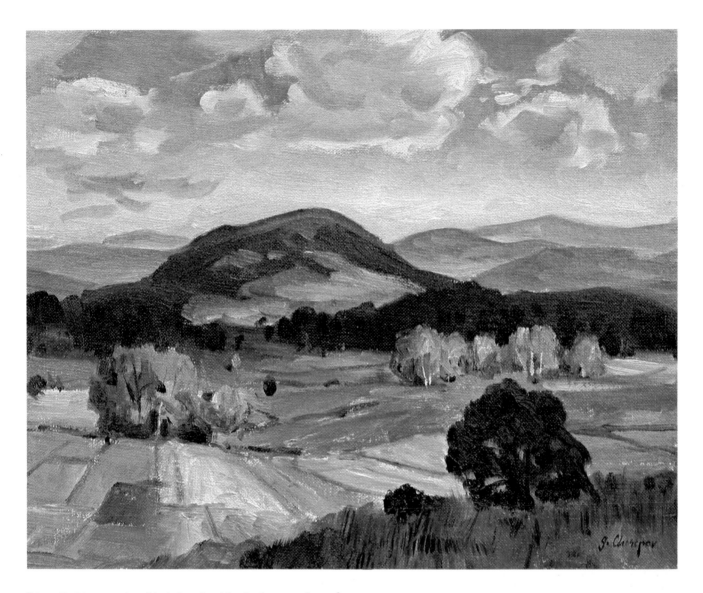

Step 7. The round softhair brush adds the last touches of detail—often so subtle that you must look closely to find them. The dark tree in the foreground is adjusted with strokes of ultramarine blue, burnt sienna, and yellow ochre, making the tree darker still and pitching it slightly to the side. Notice how several gaps are left in the foliage for the sun to shine through. A dark bush is added to the foreground with the same mixture, and dark blades of grass are added. Touches of the same mixture are added within the darkness of the woods at the base of the big hill, suggesting individual trees. Then a bristle brush repaints the sunlit trees—just above the dark tree in the lower right—with rougher, heavier strokes of the original mixture, but with a little more red. The center of the meadow is darkened and warmed in exactly the same way to accentuate the sunny fields in the foreground. These fields are made even sunnier with strokes of cadmium yellow, white and just a little ultramarine blue. The round brush finally comes back to add a few white wisps of clouds in the upper right area, some white trunks among the distant trees, a few touches of darkness among the trees, and more lines between the fields.

Step 1. When you paint a group of trees, start out by drawing the trunks with some care, but don't try to draw the precise shapes of the clusters of leaves. Try to visualize each cluster as a big, simple shape, then draw a quick line around the shape—bearing in mind that this line will soon disappear. This autumn landscape begins with a brush drawing in burnt umber that defines the main treetrunks and the edge of the shore but merely suggests a few other trunks, branches, and leafy masses. The leaves are begun as a flat, scrubby tone of cadmium yellow and a little burnt umber.

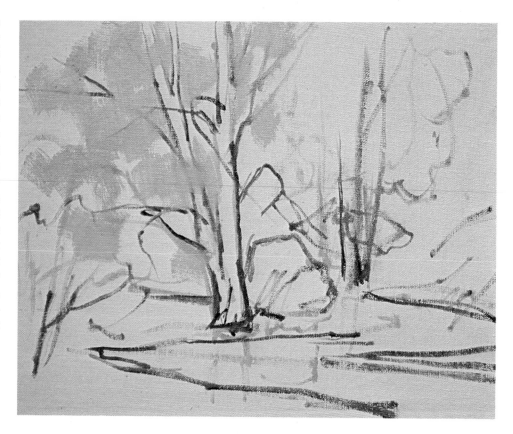

Step 2. The yellow shapes of the leaves of the main tree are extended outward with more of the same mixture. Then some shadows are suggested with cadmium yellow, yellow ochre, and burnt umber. These mixtures are carried downward into the water, which will reflect the colors of the surrounding foliage.

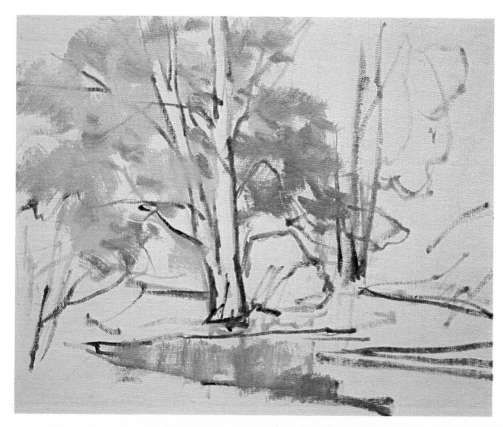

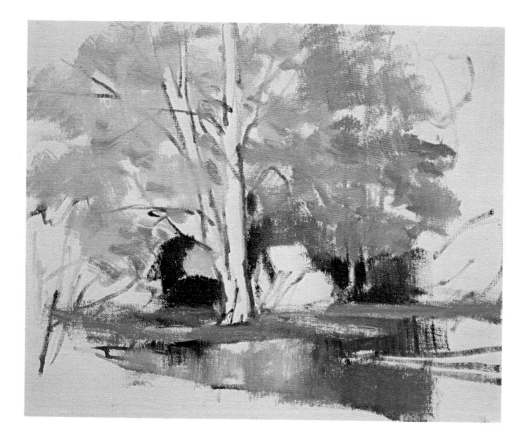

Step 3. To paint the coppery tone of the distant trees, some cadmium red and burnt sienna are added to the cadmium yellow. This same mixture is brushed along the shoreline. Some darks are added with burnt sienna and ultramarine blue, and some dark reflections are added to the water with these mixtures.

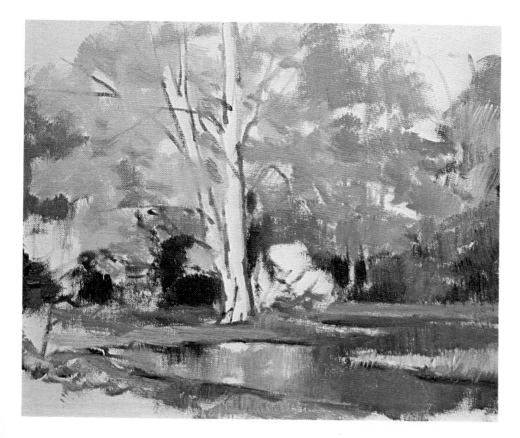

Step 4. Green foliage is added at the right with viridian, burnt sienna, and a slight touch of phthalocyanine blue—which must be added in tiny quantities, or it will dominate the mixture. This same mixture is carried down into the water to reflect the trees above. Some viridian, burnt sienna, and white are added to the near shore and along the left side of the picture.

Step 5. The bright color of the bush at the bottom of the central tree is painted with alizarin crimson, white, and a hint of ultramarine blue. The copper tone of the foliage at the left is burnt sienna, cadmium yellow, and ultramarine blue. The near shoreline is covered with the same mixture that first appeared in Step 4. And the sky is covered with free strokes of cobalt blue, alizarin crimson, yellow ochre, and white. Notice how spots of sky tone appear through the foliage.

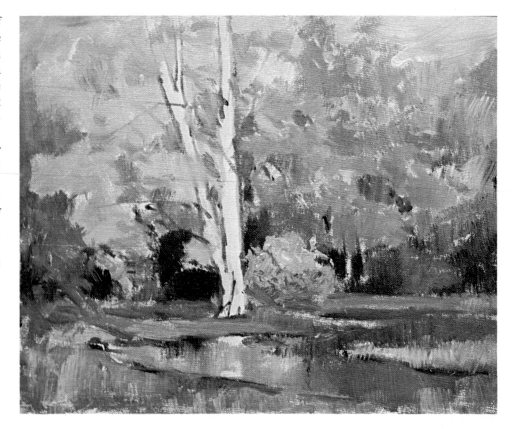

Step 6. So far, the entire canvas is covered with color—expect for the two trunks of the central tree—and it's time to start adding details. The central trunks are painted with short, thick strokes of the same mixture as appears in the sky, but with more white. Then the round brush picks up a fluid mixture of burnt umber and ultramarine blue to add dark trunks and branches. As soon as these dark lines are added, the scrubby strokes in Step 5 are transformed into clusters of leaves. Notice how the colors of the trunks are reflected in the water—a little softer and less distinct.

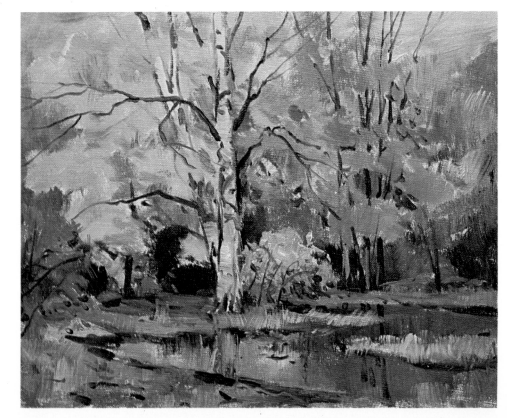

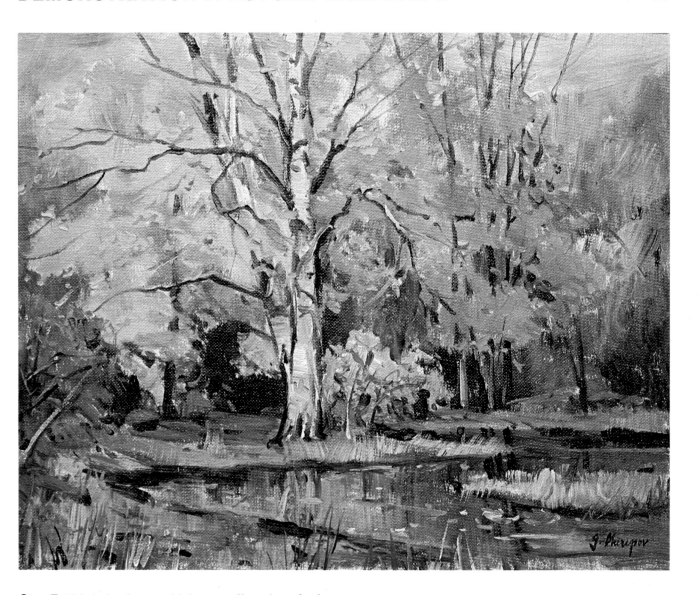

Step 7. This is the time to add those small touches of color that *suggest* so much more detail than you actually see if you look closely at the picture. The tip of a small bristle brush adds thick dabs of cadmium yellow and white here and there among the foliage of the central tree, making you think that you see individual leaves—although you really don't. In the same way, flecks of cadmium red and cadmium yellow are added to the orange trees at the right and among the coppery foliage at the extreme left. Flecks of white and yellow are added to the pond to suggest floating leaves. Dried grasses and weeds are suggested with the tip of a round brush carrying a pale mixture of white, yellow ochre, and burnt umber. More foliage tones are added to the pond. Notice how the brushstrokes express the forms: those last bits of foliage are painted with short, choppy strokes; the branches are painted with wandering, rhythmic strokes; while the reflections in the pond are painted with vertical strokes.

Step 1. Because a winter landscape has a generally cool tone, it's best to use a cool color for your preliminary brush drawing. You can use cobalt or ultramarine blue diluted with a lot of turpentine, or you can use a mixture of blue and burnt umber, as you see here. This brush drawing indicates the shapes of the trunks, the edges of the stream, the tops of the snowdrifts, and the horizon line. When you paint a landscape, it's often a good idea to work from the top down. The sky is begun with cobalt blue and white.

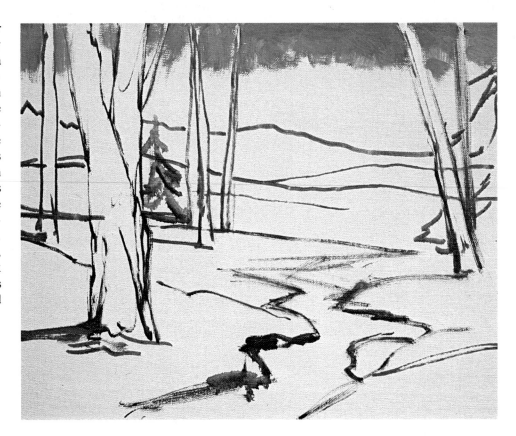

Step 2. To suggest a glow of warm light in the lower sky, a mixture of yellow ochre, alizarin crimson, and white is brushed upward from the horizon. When you're painting a snow scene, it's particularly important to get the sky tone right. After all, snow is just crystallized water; like water, the snow will reflect the colors of the sky.

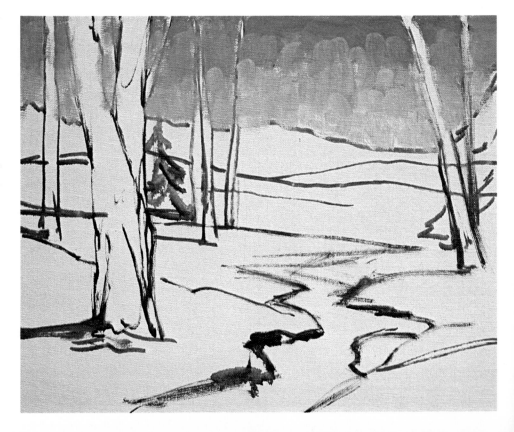

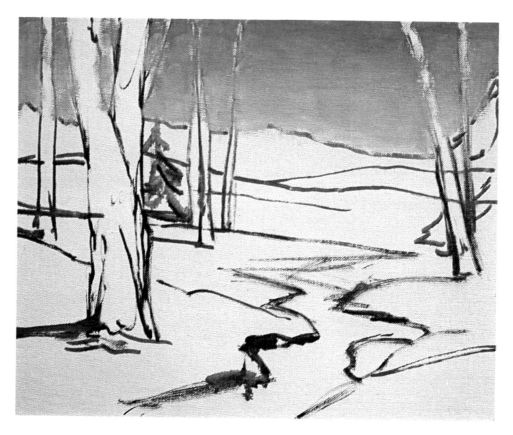

Step 3. The strokes of the sky are blended with a flat softhair brush. Now the warm tone at the horizon merges softly with the cooler tone at the top of the picture. Look carefully at skies and you'll see that the color is often darkest and coolest at the top, gradually growing warmer and paler toward the horizon.

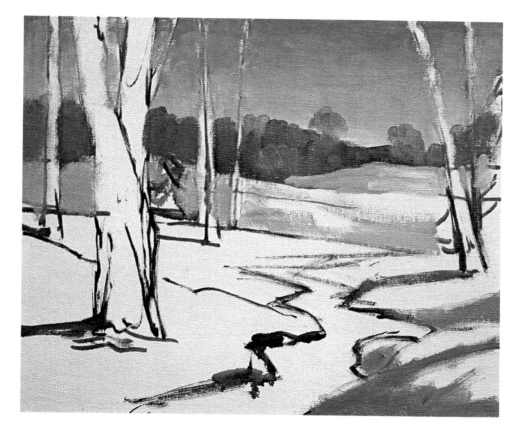

Step 4. The shadows of the snow reflect the color of the sky, so they're painted with the same mixture of cobalt blue, alizarin crimson, and yellow ochre, plus white. The lighted areas of the snow are still left bare canvas. The same three colors are used to paint the distant woods along the horizon, but with more alizarin crimson and yellow ochre added to produce a warmer tone.

Step 5. The sunlit tops of the snowbanks are painted with white that's tinted with just a touch of yellow ochre and cadmium red to add a hint of warmth. The lights and shadows of the snowbanks are blended together to produce a soft transition. The distant treetrunks are painted with the mixture that was used for the trees along the horizon. The big tree to the left is begun with a rough stroke of this mixture to indicate a shadow.

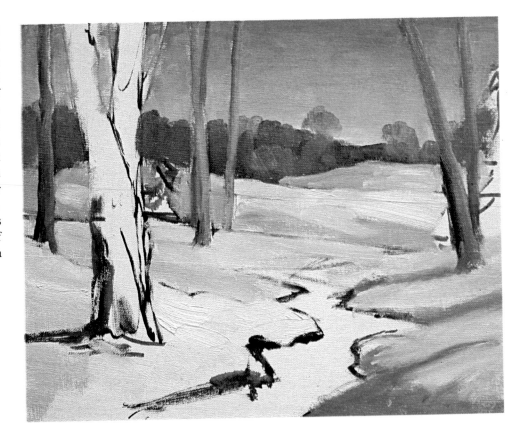

Step 6. The big tree is now covered with rough, thick strokes of burnt sienna, yellow ochre, viridian, and white—with more white in the sunlit patches. The roughness of the brushwork matches the roughness of the bark. The dark tone of the brook is painted with fluid strokes of viridian, ultramarine blue, and yellow ochre; a few white lines are added with the tip of a round brush. The same greenish mixture is used to suggest an evergreen in the upper left area. Two more distant trees are added with the same mixture used for those at the horizon.

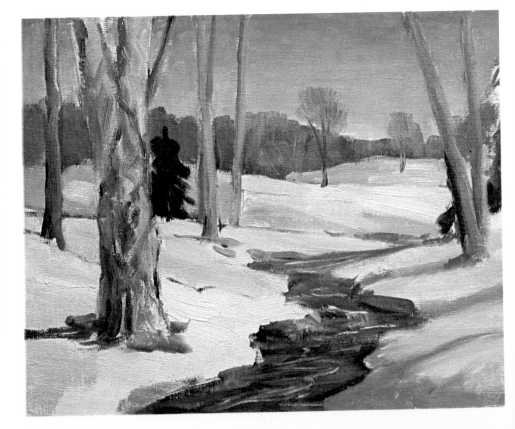

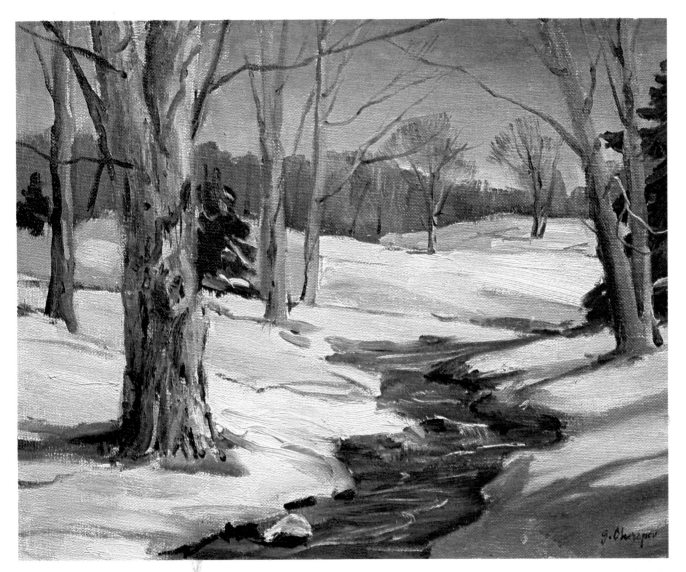

Step 7. Another evergreen is added at the right with the mixture used in Step 6. A bristle brush strengthens the shadows on the snow with the mixture introduced in Step 4. Then another bristle brush builds up the lighted areas of the snow with the mixture used in Step 5. Around the big tree, you can see that much thicker paint is used for the lights than for the shadows—a good rule to follow. Then a small round brush uses the original tree mixtures to draw branches, twigs, and shadows along the trunks. The curve of the snow is accentuated by slender lines that suggest shadows cast by the branches. The dark lines along the edges of the stream and on the big trunk are drawn by the tip of the round brush carrying a mixture of viridian and burnt umber. A few strokes of pure white are added to suggest snow on the branches, on the distant evergreen, and on the rock in the stream.

Step 1. When you sketch in the first lines of a portrait head, start with the biggest shapes. Draw the curving sides of the face, the mass of the hair, the neck, and the shoulders. Then draw a pale, horizontal line about halfway down the face to indicate the location of the eyes. To harmonize with the warm flesh tone, this preliminary brush drawing is done with burnt sienna diluted and lightened with turpentine.

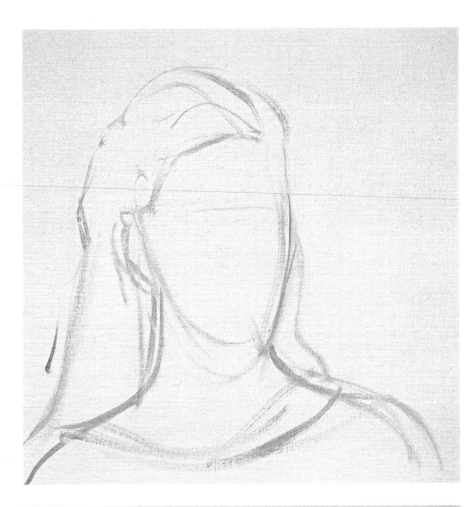

Step 2. When you've drawn the biggest forms simply but accurately, then you can add the features. Notice how these features are placed within the egg-shape of the face. The eyes are roughly halfway down from the top of the head. The tip of the nose is about halfway between the eyes and chin. And the mouth is about halfway between the tip of the nose and the tip of the chin. The top of the ear aligns with the eyes, while the lobe falls somewhere between the nose and the upper lip.

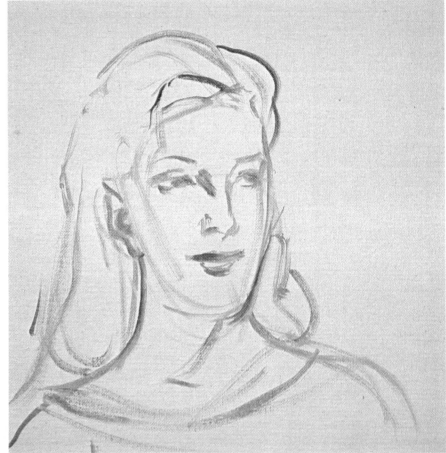

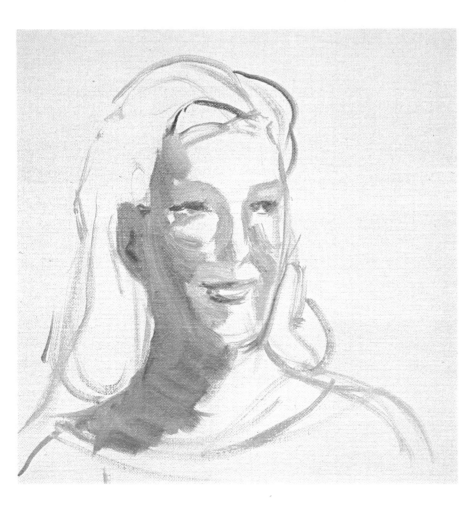

Step 3. A large bristle brush paints the shadow tone that runs from the brow over the cheek, jaw, neck, and shoulder. This is a mixture of yellow ochre, cadmium red, and cobalt blue. This same mixture is carried into the eye sockets, along the side of the nose, beside the other cheek, and along the side of the mouth. You can see that some strokes contain more red and others more blue. The bright tone of the ears is this mixture, but with much more red. Don't worry if the underlying brushlines begin to disappear; they're not meant to be anything more than guidelines to be followed freely when you brush in the big areas of color.

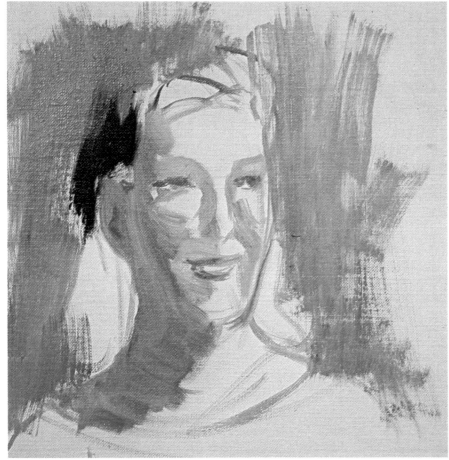

Step 4. The same mixture used in Step 3, but with more blue and yellow, is brushed freely over the background and carried to the edges of the face and hair. The guidelines of the hair almost disappear under this background tone. But then dark strokes of ultramarine blue, burnt umber, and yellow ochre start to re-establish the dark shape of the hair. At this point, several important color areas are clearly established: the lighted areas of the face, which are still bare canvas; the shadow areas of the face; and the tone of the background.

Step 5. The entire shape of the hair is covered with the dark mixture of burnt umber, ultramarine blue, yellow ochre, and a bit of white, painted with broad strokes that follow the curve of the hair. This dark shape is important because it clearly defines the lighter contours of the forehead, cheek, jaw, ear, neck, and shoulders. Now, even though the head is very roughly painted, it looks strongly three-dimensional.

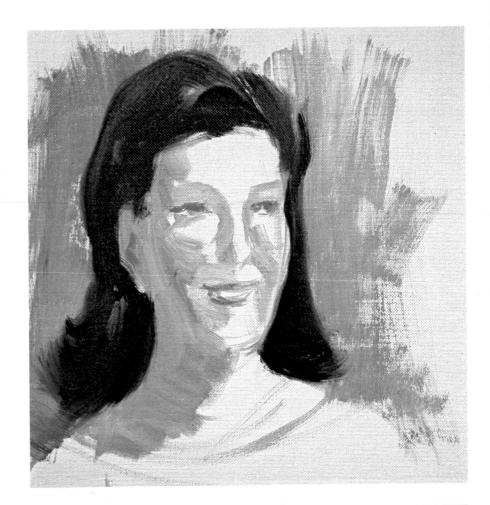

Step 6. The lighted areas of the face are brushed in with the same mixture as was used for the shadows, but with much more white. These areas are painted with a flat softhair brush that carefully blends the light and shadow areas where they meet. The shadow areas are painted more precisely with the original mixture, adding a bit more red around the cheeks and adding a touch of burnt umber to the dark shadow that runs over the throat. A round brush adds small touches of the hair mixture to the eyes, eyelashes, eyebrows, nostrils, and the hollow of the ear. This same brush suggests some individual strands of hair with the original hair mixture, which now contains more white and yellow ochre. The lips are painted with the same mixture as the flesh, but with more red.

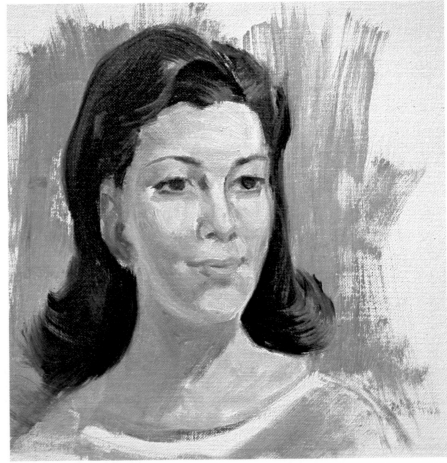

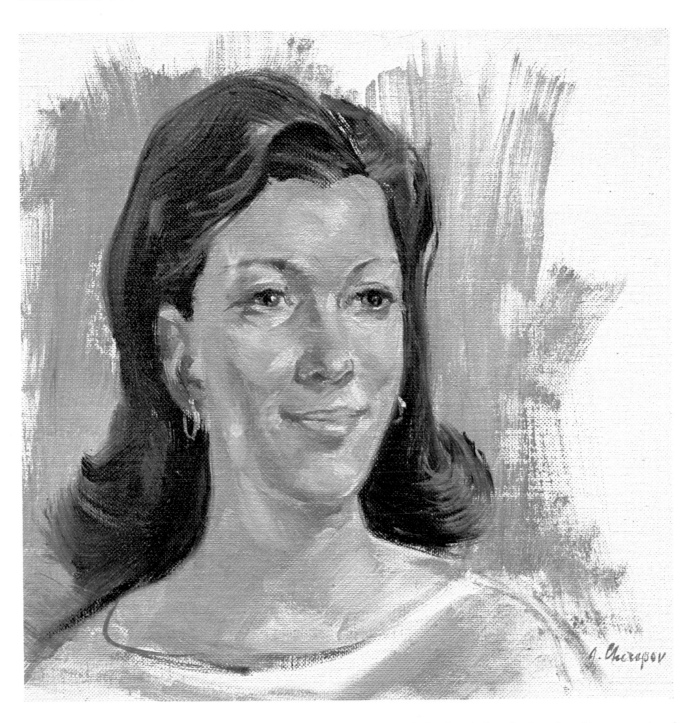

Step 7. By the end of Step 6, the entire head is covered with broad tones and a few touches of detail. In the final stage, these tones are made richer amd more lifelike with small strokes of flat and round softhair brushes. Notice how small touches of warm color are softly blended into the forehead and between the eyes; around the eye sockets and the curves of the cheeks; to the sides and tip of the nose; and down over the jaw and chin. The shadows around the eye sockets, under the nose, under the lower lip, and under the chin are strengthened. Touches of pale color are added to the center of the forehead, the cheeks, the tip of the nose and ear, the lower lip, and the chin, which become more luminous. All these touches are done with the original mixture used for the shadow in Step 3, with more red and yellow added for the warm tones and more white added for the highlights. The eyes are darkened with small, precise strokes of the hair mixture, and then tiny touches of white are added for the highlights. The loose brushwork of the background is left untouched, and the dress is merely suggested with rough strokes of cadmium red and cadmium yellow. The hair is almost as loosely painted as the background. The gold earrings are nothing more than quick strokes of yellow ochre and white. The careful brushwork is limited to the face—but even here, the strokes are never *too* precise.

TO15840

Step 1. This male head, like the female head in Demonstration 9, begins with a brush drawing that simply defines the outer shape of the head, the contour of the hair, and a bit of the neck and shoulders. A horizontal line is drawn to locate the brow, and a shorter horizontal line locates the tip of the nose. This preliminary brush drawing is a fluid mixture of burnt umber and cobalt blue.

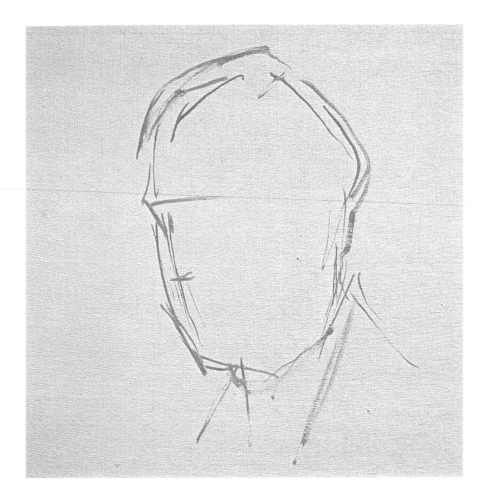

Step 2. Now the smaller forms are drawn with darker lines over the big, simple form in Step 1. The brush defines the distinctive shapes of the brows, eyes, cheeks, nose, mouth, jaw, chin, and ear, as well as the inner line of the hair. Once again, notice that the eyes are about halfway down, the nose is midway between the eyes and chin, and the mouth is roughly midway between the nose and chin. The top of the ear lines up with the corner of the eye, while the lobe lines up with the nostril.

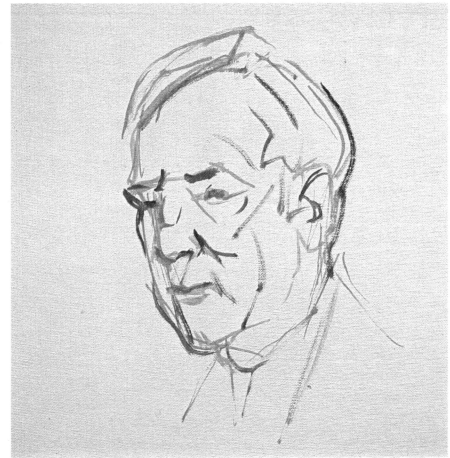

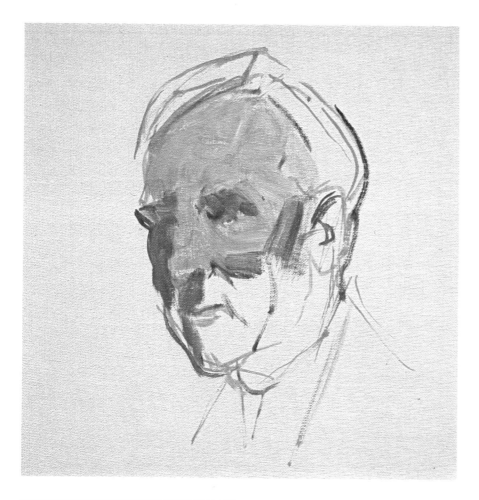

Step 3. At this stage in the portrait, the most important thing is to establish the broad areas of light and shadow. Now they're painted at the same time, with one brush carrying the light mixture over the forehead, nose, and cheek, while the other brush carries the shadow mixture over the eye sockets, then down over the cheeks, upper lip, and chin. Both these tones are a mixture of yellow ochre, cadmium red, and cobalt blue, with more white in the light areas.

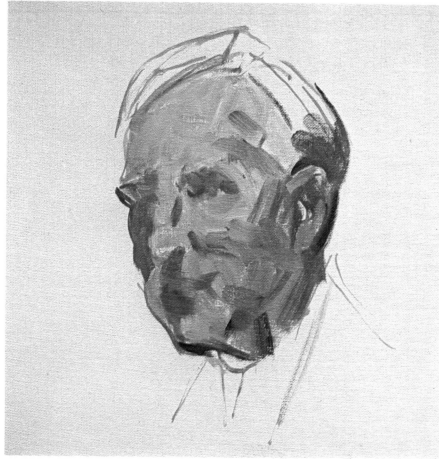

Step 4. The entire face is covered with rough patches of these light and shadow mixtures. A bit of burnt sienna is added in the darker areas. The original brush lines, drawn in Steps 1 and 2, have almost completely disappeared under broad strokes of color. But the head already begins to look round and lifelike, even though the details of the drawing have been obliterated.

Step 5. A background tone of cobalt blue, yellow ochre, and white is brushed freely around the head. So far, all the work has been done with bristle brushes. Now smaller flat and round sables reconstruct the contours of the head with dark strokes of burnt sienna, ultramarine blue, yellow ochre, and white. You can see where crisp strokes and lines have been drawn into the eyes and ear; around the outer edge of the brow, cheek, jaw, and chin; and in the shadow areas beneath the cheeks, nose, lower lip, and jaw. The hair is painted with free strokes of cobalt blue, burnt umber, and white, with a few lines of the dark mixture used on the face.

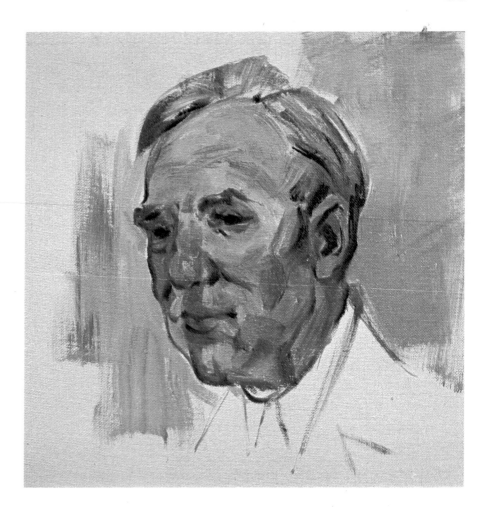

Step 6. The background tone is carried out toward the edges of the canvas. Then the same softhair brushes are used to strengthen the contrasts within the face. Lighter strokes of the original flesh tone—with more white—are blended into the center of the forehead, into the nose, around the eye sockets and mouth, over the edges of the ear, and down into the neck. The shadows of the eye sockets, nose, lips, cheeks, and chin are repainted with a darker version of the flesh mixture. Then the lights and shadows are blended softly into one another. The hair is developed with more precise strokes of cobalt blue, burnt umber, and white. The same mixture is repeated in the collar.

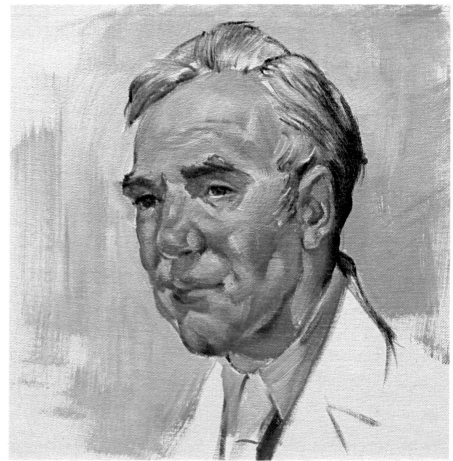

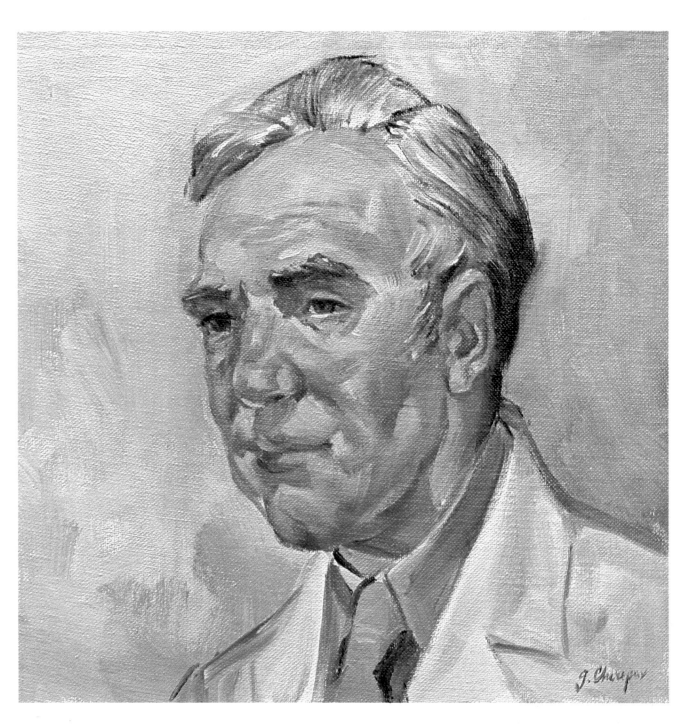

Step 7. Step 6 comes very close to being a finished portrait, but there are still a few refinements to be added in Step 7. The background tone is carried to the outer edges of the canvas and lightened with more yellow ochre and white along the front of the face in order to strengthen the contrast between the pale background and the darker flesh tones. As the background tone is painted along the brow, cheek, jaw, and chin, the contours of the face are made rounder and softer. Paler flesh tones are brushed in along the edge of the face to make them softer and more luminous. As you run your eye over the entire face, you can see other light touches that add luminosity: touches of pale flesh tone above the brows and around the eye sockets; touches of warmth in the cheeks; pale strokes within the shadows to make them look more transparent. Observe how the strokes on the cheeks and forehead curve around these bony forms. It's these last, almost invisible, touches that add vitality to the portrait. The jacket, by the way, is the same mixture as the hair, while the necktie is cadmium yellow subdued with a touch of cobalt blue and burnt umber, then lighted with white.

Step 1. A coastal scene, dominated by sky and water, is an interesting challenge. This painting is done on a gesso panel—a sheet of hardboard coated with white acrylic gesso, thinly applied so that the dark tone of the hardboard comes through slightly. The preliminary brush drawing defines the horizon, the rocks along the shore, the distant headland, and the cliff in the lower right area. This is a picture with strong contrasts, so the lines are drawn with a dark mixture of ultramarine blue and burnt umber.

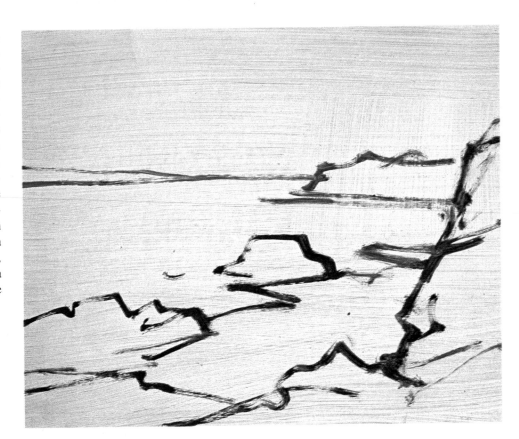

Step 2. The strip of land along the distant shore, the headland just below the horizon, and the first tones of the beach are painted with a mixture of ultramarine blue, yellow ochre, alizarin crimson, and white. More blue is used in the distant form, while more red and yellow appear in the strokes along the beach.

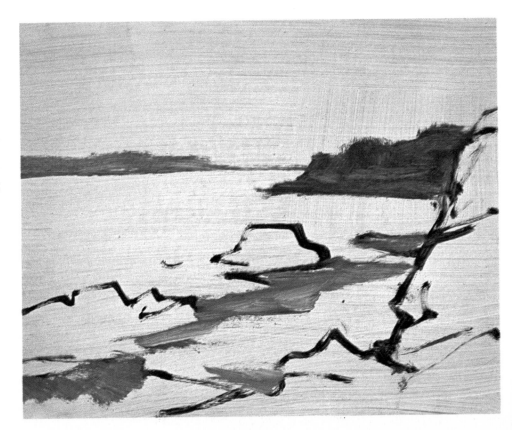

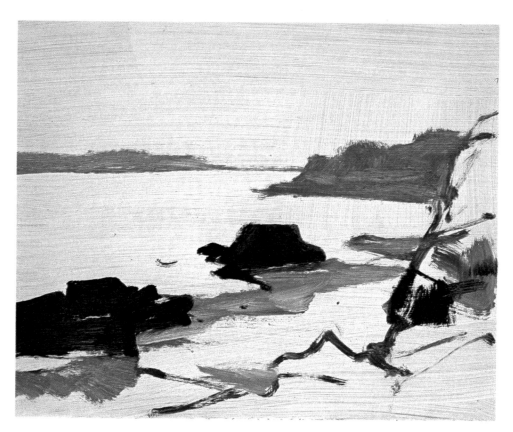

Step 3. The dark forms of the rock are painted in flat tones of ultramarine blue and burnt umber. The cliff to the right is begun with the same mixture. What makes this painting interesting is the pattern of dark, rocky shapes against the lighter sky and water. So the first goal is to place these shapes in their proper positions on the panel.

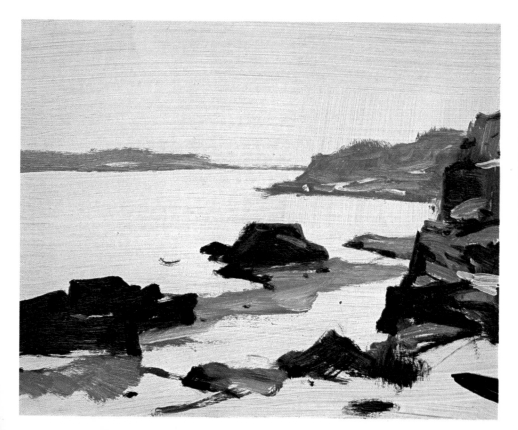

Step 4. The cliff is covered with the dark mixture of ultramarine blue and burnt umber. Then the distant shore and headland are repainted with thicker strokes of the original mixture used in Step 2, but with more blue and white. Strokes of this same mixture indicate lighted tops on the rocky forms within the cliffs to the right. A single stroke of this mixture appears on the top of the central rock.

Step 5. The sky is painted with overlapping, short, irregular strokes of cobalt blue, yellow ochre, alizarin crimson, and white—with more red and yellow toward the horizon. You probably remember that this is similar to the mixture used to paint the distant shore and headland. The sky is bluest and darkest at the top, paler and warmer at the horizon.

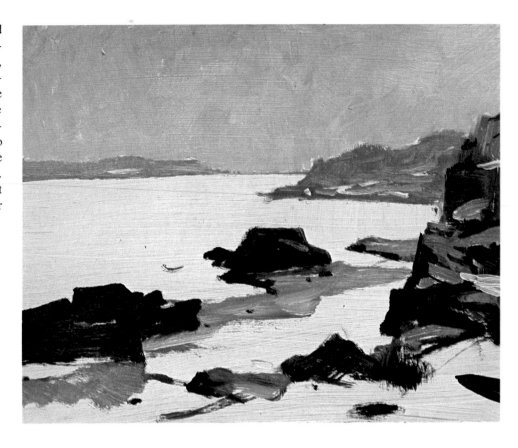

Step 6. Since water normally reflects the color of the sky, the sky mixture now reappears in the rough strokes of the crashing waves just beyond the rocks. To the beach between the rocks and the nearby cliff, a painting knife adds thick strokes of white, slightly tinted with the sky mixture; later, these white strokes will be transformed into wet, shining sand.

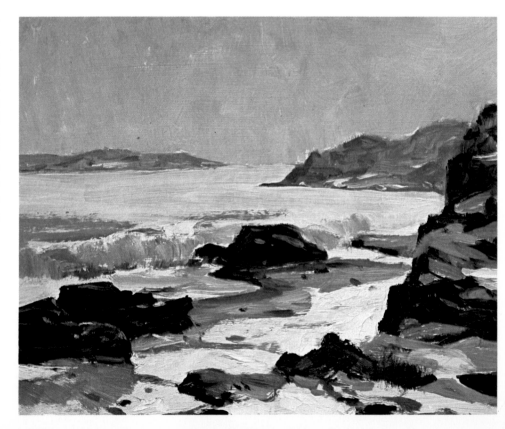

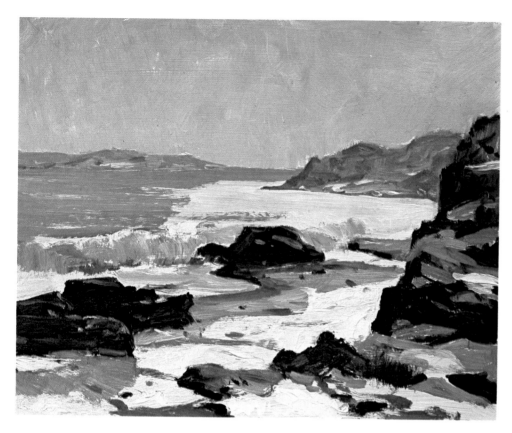

Step 7. Now the sea beyond the crashing waves is begun with horizontal strokes of the sky mixture. It's darker because it contains less white, but it's still a blend of cobalt blue, alizarin crimson, yellow ochre, and white. The sunlit edge of the crashing wave is the same white that appears on the beach, faintly tinted with the sky tone.

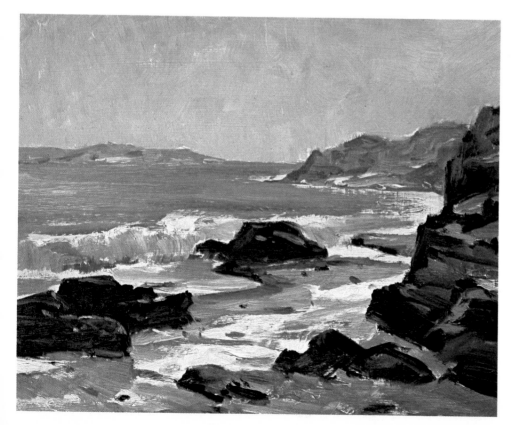

Step 8. The tone of the water is carried across to the beach at the right, where a bit of the tinted white is blended in to suggest sunlight shining on the wet sand. The sand in the immediate foreground is painted with the sky mixture too, but dominated by alizarin crimson and yellow ochre. This tone is brushed over the heavy strokes of white on the shining beach. The rocks along the lower edge of the picture are defined with dark strokes of burnt umber and ultramarine blue.

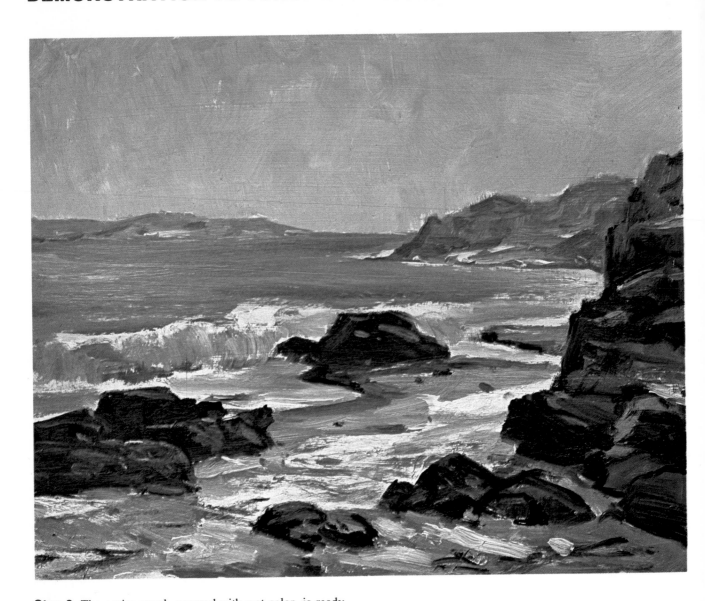

Step 9. The entire panel, covered with wet color, is ready for the final touches. Strokes of white tinted with the sky tone are carried across the beach in the foreground to suggest the reflections in the wet sand. A few strokes of burnt sienna and yellow ochre add a touch of warmth to the rocks at the extreme left. Beneath these rocks, strokes of cadmium yellow, slightly dimmed with cobalt blue, suggest scraps of seaweed. More strokes of sandy shore color are dragged lightly over the shining white just beyond the foreground rocks. The tip of a round brush is dipped into a dark mixture of ivory black, burnt umber, and ultramarine blue to draw dark lines that define the rocks and cliff more precisely. These dark lines deepen the shadows and add more cracks between the rocks. Notice the small, dark flecks scattered here and there along the beach to suggest pebbles.

Correcting as You Work. While you're working on a painting, there will certainly be times when you want to change your mind. You may want to move a couple of trees closer together, simplify the shape of a cloud, paint the grass a brighter color, or simply eliminate a distracting rock. If you want to make these changes while the painting is still wet, don't try to cover up your "mistake" by just painting over it. The underlying paint is apt to work its way up into the new strokes and make the repainting job a lot harder. Furthermore, when you pile wet paint on top of wet paint, the surface of the picture starts to get wet and gummy, making the fresh paint hard to push around. Before you repaint any part of a picture, it's always best to remove as much wet color as you can. Scrape that first layer of paint with the side of your palette knife and wipe the blade of the knife on a rag, a paper towel, or a sheet of newspaper. Don't try to reuse the paint you've taken off.

Scraping and Repainting. When you scrape off some unsatisfactory section of the painting, you won't get down to bare, white canvas. The knife doesn't take off every trace of wet paint, but leaves a "ghost" of that tree you wanted to move or that rock you wanted to delete. This is no problem. A fresh layer of color will easily cover what's left of the underlying paint. In fact, that "ghost" has two advantages. Just a faint trace of wet color on the canvas will actually make your brush move more easily over the painting—it can be a very pleasant surface to work on. And that pale image can serve as a helpful guide for your brush to follow.

Wiping out and Repainting. Of course, many artists find that "ghost" image distracting. When they want to make a change, they prefer to eliminate as much of the underlying image as they can. Then the solution is to take a tough, lint-free rag, dip it in turpentine or mineral spirits (white spirit in Britain), and scrub away the wet color. If the paint is fairly thick, it's a good idea to scrape it first with a palette knife. This takes off all the paint that sticks up from the surface. After the scraping, you can use the rag and solvent to dig further into the fibers of the canvas and get rid of the "ghost" that's left by the scraping.

Repainting a Dry Canvas. What if the picture has sat around the studio for a week or more—which probably means that it's now dry to the touch? You can't remove the image easily, but it *is* easy to paint over the dry surface. Start by working over the surface gently with fine sandpaper or steel wool; this will take off some of the paint and roughen the surface slightly so that it becomes more receptive to new brushwork. Then it's a good idea to moisten the surface with just a bit of medium. Dip a clean, lint-free rag in your mixture of linseed oil and turpentine—or one of the more exotic mediums you read about earlier—and wipe the rag over the area you expect to repaint. The canvas should be slightly moist, giving you the pleasant sensation that you're working on a wet painting after all. But the canvas shouldn't be so wet and shiny that the brush slithers over the surface and the bristles don't dig in; if the canvas seems too wet, wipe it gently with a dry rag, leaving the surface just faintly moist.

Maintaining Spontaneity. When you repaint some part of a picture, one of the hardest jobs is to make the repainted portion look as spontaneous as the rest of the picture. The most important advice is: don't be too careful! When you scrape out or wipe out some section of a wet painting, don't be too neat. Scrape or scrub vigorously. Don't remove the offending section so carefully that you leave a neat, sharp edge looking as if you've done the job with a scissors. Leave the edge a bit rough and blurry. Don't worry if you scrape or scrub a bit beyond the area you expect to repaint. For example, if you're scraping out the cheek of a portrait head, don't try to preserve every stroke of the background tone that appears next to the cheek. It's better to take out the cheek and a little of the background tone as well. Then, when you repaint the cheek, you'll have to repaint some of the background too. And you'll feel free to paint both cheek and background with bold strokes.

Be Ruthless. Nothing is more painful than trying to remove and repaint some section of a picture that does contain some good parts. What do you do when the foliage of the tree seems wrong, but you've done a particularly good job with the branches buried among the foliage? Can you scrape away the foliage and manage, somehow, to preserve the brushwork of the branches? Probably not. If you try to scrape or wipe too neatly around those branches, they'll never look like they're part of the same tree when you repaint fresh foliage around them. It's better to be ruthless and scrape off the leaves and branches together. Repaint them both with bold strokes. After all, if you got the branches right the first time, you can do it again!

Step 1. This bouquet of flowers looks too neat and lacks variety because all the blooms are roughly the same size. The blooms need to be distributed in a more casual way and painted with more gusto. The vase is also dull because it lacks strong light-and-dark contrast. The floral decoration on the side of the vase lends nothing to the picture.

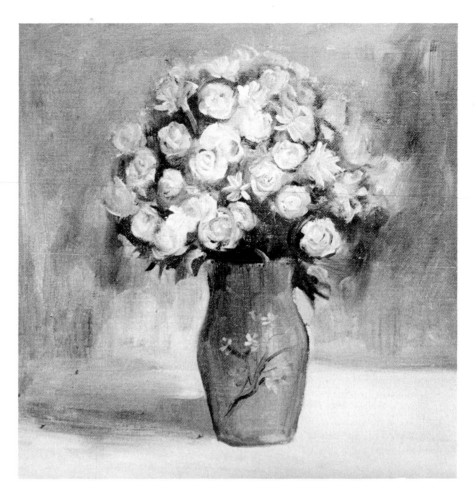

Step 2. The flowers and vase are scraped with the side of the palette knife. This scraping operation doesn't remove all the color. Most of the paint is removed, but you can still see a "ghost" image of the flowers. The general shape of the vase remains intact, making it easier to repaint. However, enough paint has been removed to reveal the texture of the canvas—which will *feel* like bare canvas when the brush goes back to work.

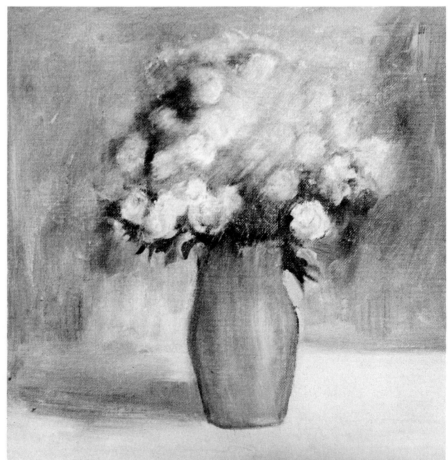

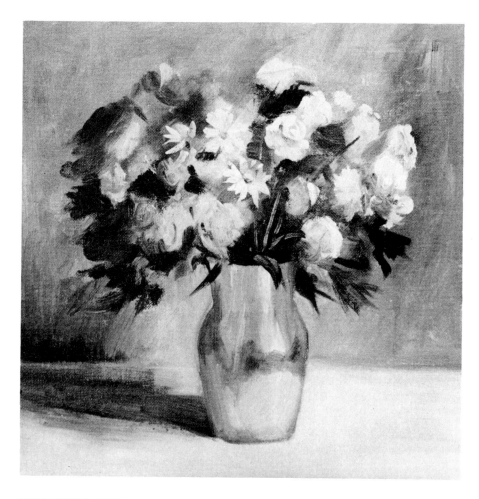

Step 3. The flowers are rearranged in a looser, more "accidental" design. The lighting is changed so that there are stronger contrasts of light and shade within the bouquet and on the vase, plus shadows on the tabletop and wall. The new bouquet is begun with rough, free strokes that quickly cover the "ghost" image in Step 2. The bold strokes of light and shadow on the vase rapidly cover the pale tone that remained in Step 2.

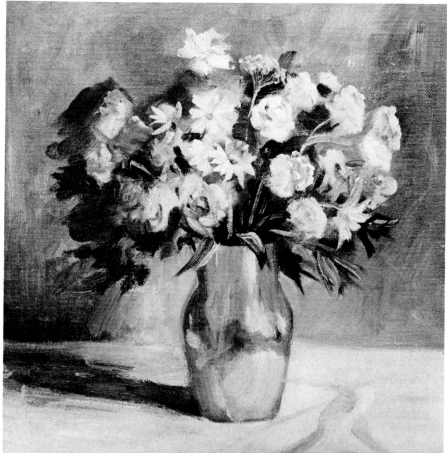

Step 4. Smaller strokes are added to the flowers to suggest petals and stems. But most of the brushwork remains loose and suggestive, unlike the tighter brushwork in the original painting shown in Step 1. Highlights are added to the vase, and the contours are sharpened. The shadows on the tabletop and wall are strengthened. The "ghost" image in Step 2 has served as a guide, particularly in the repainting of the vase, but now the original painting has disappeared totally under the new, more vigorous brushwork.

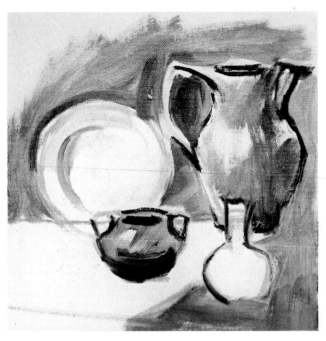

Step 1. The entire composition of this still life is wrong. The pitcher faces outward and leads the eye away from the center of the painting. The two smaller vessels need to be relocated. Only the dish seems to be in the right place.

Step 2. Scraping the painting won't work—the knife won't take off enough paint to remove the pitcher and the two smaller vessels that need to be relocated. A clean, lint-free rag is dipped in turpentine or mineral spirits. The canvas is scrubbed until the three forms disappear entirely. A faint tone remains, but this will be covered easily when the picture is repainted.

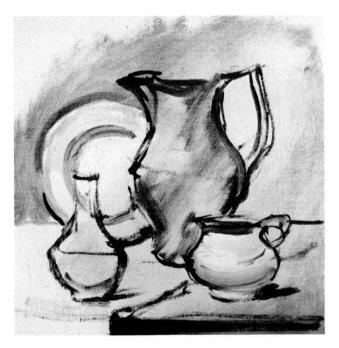

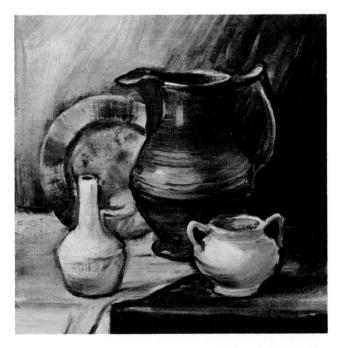

Step 3. With fluid color diluted with plenty of solvent, the pitcher is turned around and relocated so that it occupies the focal point of the painting. The small vase and pot are transposed. The four objects are now regrouped so that they overlap and join forces to make a more unified pictorial design.

Step 4. The still life is now completed with strokes of heavier color. The pale tone that remains in Step 2 is now completely covered with fresh color. There's no trace of the original location of the still life objects that appeared in Step 1.

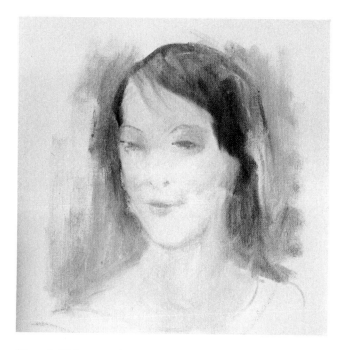

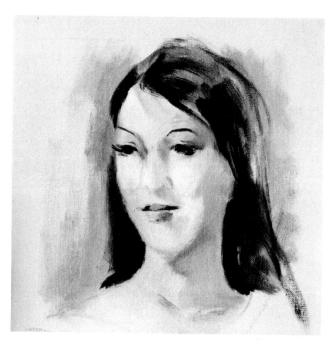

Step 1. This portrait head is much too pale and the shapes are too vague. The painting is dry, however, which means that it's too late to scrape off the original color with a knife or scrub it off with a rag.

Step 2. The solution is to remove the more prominent brushstrokes with fine sandpaper or steel wool, which also roughens the surface of the canvas and makes it more receptive to fresh brushwork. Then the surface is moistened with a clean rag dipped into just a bit of medium. When fresh paint is applied to this moist surface, the brush feels as if it's moving over a wet painting.

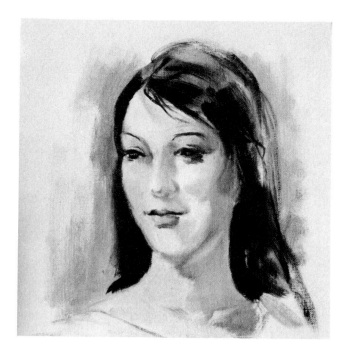

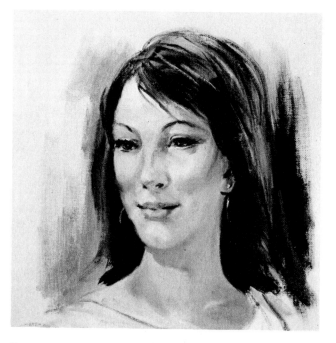

Step 3. The hair, the shadows on the face and neck, and the dark tones of the features are repainted with bold strokes and darker color. As the brush moves over the damp surface, the strokes seem to melt softly into the canvas.

Step 4. In the completed painting, the two layers of color—dry below and wet above—look like one continuous layer of wet paint. Working on a moist surface makes all the difference. The new strokes would look harsh if they were painted on dry canvas.

Fallen Tree and Grass. The traditional term for thick paint is the Italian word *impasto*. Strokes of thick, pasty color are a simple way to render rough, irregular textures such as this fallen tree with its rough bark, broken branches, and twisted network of roots. The thick strokes of the bark literally stick up from the canvas. Some of the foreground weeds are also painted with thick color that makes them seem closer than the weeds in the distance. For *impasto* brushwork, use color straight from the tube or add just a touch of painting medium—but not enough to make the paint too fluid.

Treetrunk and Rocks. But thick paint isn't the *only* way to create rough textures. You can do just the opposite. Instead of building the paint up from the surface of the canvas with *impasto* brushwork, you can scrape down into the wet paint, making grooves and deep scratches with the tip of the palette knife or the point of the brush handle. You can see such scratches running along this fallen treetrunk, giving the impression of dried, cracked bark. On the facing page, some of the sunlit weeds are painted with strokes of thick color that stand up from the canvas. But in the example on this page, the light-struck weeds are scratched out of the dark paint, revealing the paler tone of the canvas beneath.

Step 1. Like any other subject, the fallen tree begins as a brush drawing in thin color diluted with plenty of turpentine. There's no hint of the thick paint and rough brushwork that will come later. It's always best to begin with thin paint so that you can wipe away the lines with a cloth if you change your mind about the composition or the accuracy of the drawing.

Step 2. The darkest tones are painted first: the shadowy areas of the trunk and branches, the patch of shadow beneath the roots, and the jagged shadow cast by the trunk on the grass. At this stage, the paint is still quite thin and fluid, diluted with a good deal of medium.

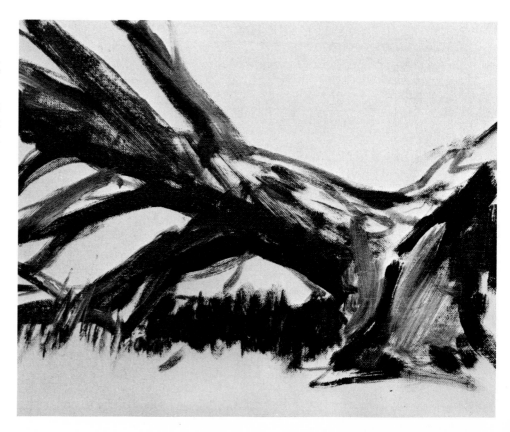

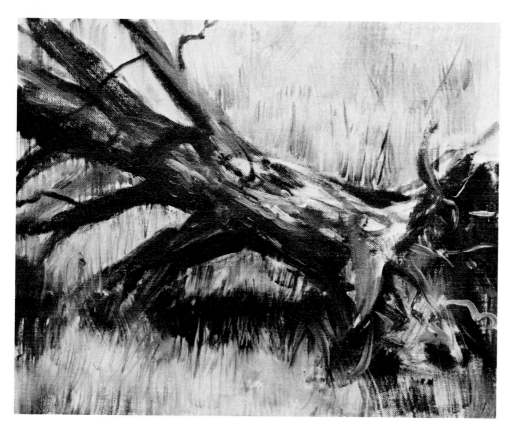

Step 3. Lighter tones are added to the trunk. The lighted areas of the grass are painted beneath the tree, between the branches, and in the meadow beyond. A few light patches appear on the bark, and some lightstruck roots are brushed over the shadow at the base of the tree. The entire canvas is covered with wet color, which is still fluid and creamy. The impasto strokes are saved for the very end.

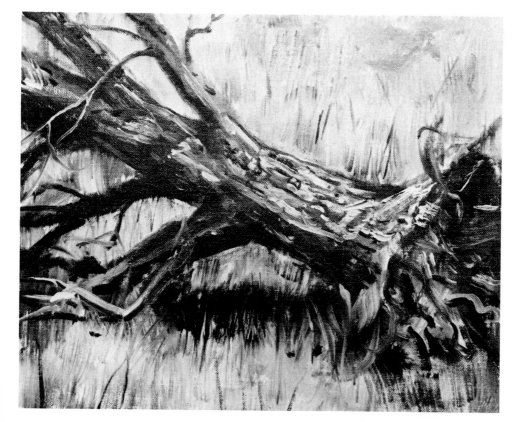

Step 4. Now the lightest tones of the bark, branches, weeds, and roots are painted with rough, quick strokes of thick color. Each impasto stroke is made with a firm, decisive movement of the brush—and the stroke is left unchanged. The rough texture of the stroke would be ironed out if the brush moved back and forth. In the finished painting, the darks remain thin and fluid; only the lights are thickly painted. In fact, most of the canvas is thinly painted, and the impasto appears only in certain areas. It's best to use impasto brushwork selectively—thick strokes will look more important if they're surrounded by thinner color.

Step 1. This outdoor "still-life"—a heavy log, rock, and weeds—begins with a simple brush drawing that defines the major shapes. There's no attempt to draw details such as the crack in the log or the weeds that will be scratched into the wet paint in the final stage.

Step 2. The trunk and rock are begun with broad strokes of a bristle brush, roughly painted so that the marks of the bristles show and express the texture of the subject. The paint on the log is thick and pasty, and many of the strokes are made with a painting knife.

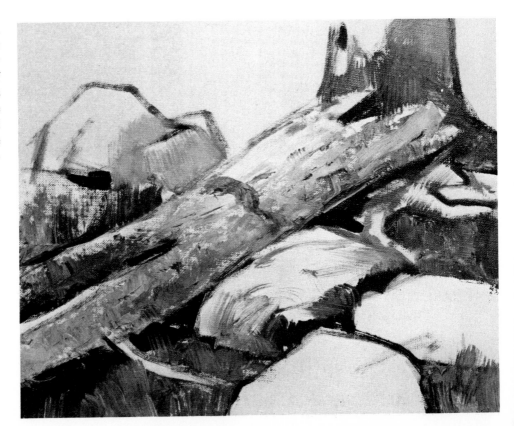

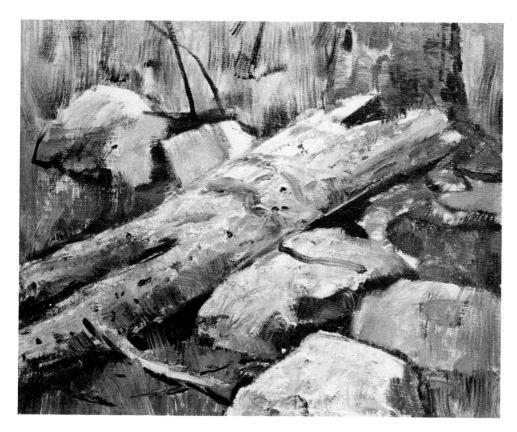

Step 3. Now the entire canvas is covered with wet color. The paint on the fallen trunk is particularly thick. When scratches are made into this thick color, they'll stand out more clearly than they would if the color were thinly applied.

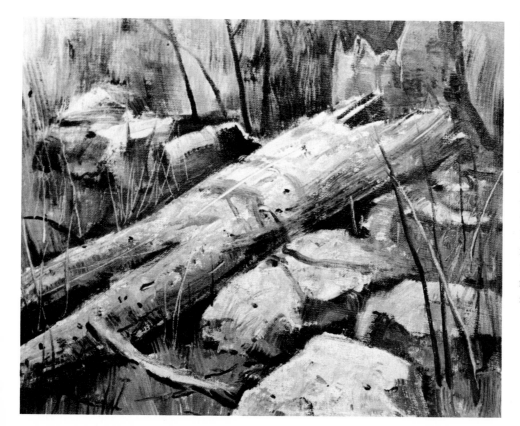

Step 4. The tip of the palette knife and the pointed end of the brush handle travel up the side of the trunk, leaving grooves and scratches that suggest the texture of the bark. More scratches become the slender strands of weeds that spring up around the sides of the trunk and among the rocks. The lighted tops of the rocks are scraped here and there with the side of the knife blade. The tip of a round brush adds some dark weeds and twigs that contrast nicely with the light scratches.

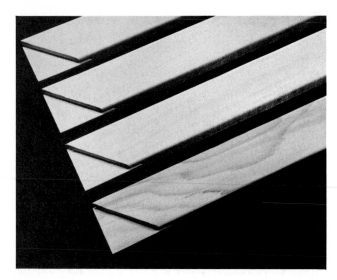

Step 1. If you want to stretch your own canvas, buy wooden stretcher bars at your art supply store. These are wooden strips with slotted ends that fit together to make a rectangular frame. You'll need four bars, one for each side of the frame. The best nails for stretching canvas are 3/8″ or 1/2″ (9-12 mm) carpet tacks.

Step 2. When you assemble the slotted stretcher bars, they should fit together tightly without the aid of nails or glue. Check them with a carpenter's square to make sure that each corner is a right angle. If the corners aren't exactly right, it's easy to adjust the bars by pushing them around a bit.

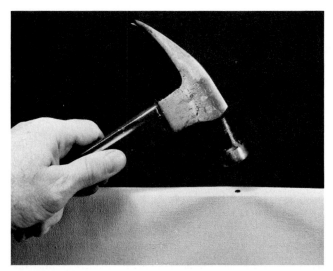

Step 3. Cut a rectangle of canvas that's roughly 2″ (50mm) larger than the stretcher frame on all four sides. As it comes from the store, one side of the canvas will be coated with white paint, and the other side will be raw fabric. Place the sheet of canvas with the white side down on a clean surface. Then center the stretcher frame on the fabric.

Step 4. Fold one side of the canvas over the stretcher bar and hammer a single nail through the canvas into the edge of the bar—at the very center. Do exactly the same thing on the opposite stretcher bar, pulling the canvas tight as a drum and hammering a nail through the canvas into the edge of the bar. Then repeat this process on the other two bars so you've got a single nail holding the canvas to the centers of all four bars.

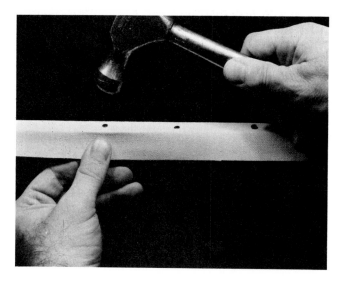

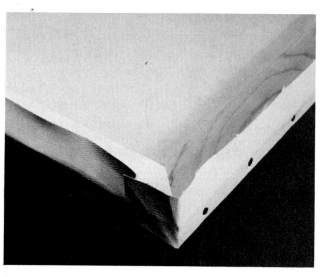

Step 5. Add two more nails to each bar—one on either side of the original nail, about 2″ (50 mm) apart. Working with the back of the canvas facing you, pull the canvas tight with one hand while you hammer with the other. Repeat this process on all four sides. Keep adding pairs of nails to each side, gradually working toward the corners. Pull the canvas as tight as you can while you hammer. At first you may have trouble getting the canvas tight and smooth. Don't hammer the nails all the way in; let the heads stick up so you can yank the nails out and try again.

Step 6. When you get to the corners, you'll find that a flap of canvas sticks out at each corner. Fold it over and tack it to the stretcher as you see here.

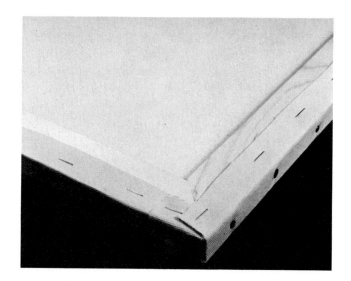

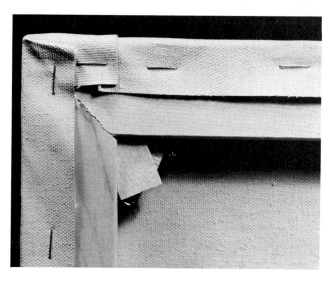

Step 7. Then fold the remaining canvas over the backs of the stretcher bars and staple it down to make a neat job. Speaking of staples, you might like to try using a staple gun for the whole job—instead of tacks or nails.

Step 8. Here's a close-up of the corner, seen from the back, showing the canvas all neatly folded and stapled down. Inside the corners of the stretcher bars you can see the ends of triangular wooden keys, which you hammer into slots to stretch the canvas tighter if it's not absolutely smooth. Your art supply store will give you the keys when you buy the stretcher bars. Hold the keys in place by hammering small tacks behind them. If the canvas starts to loosen and get wavy later on, just hammer in the keys a little further.

Cleaning Your Palette. When you're finished painting, the center of your palette will be covered with smears and dabs of wet color. Along the edges of your palette, there will probably be little mounds of half-used tube color. If you're working on a wooden palette, it's easy enough to wipe off the central mixing area with a rag or a paper towel and a little turpentine or mineral spirits (called white spirit in Britain). Wipe the surface until it's clean and shiny. If you leave a muddy film of color on the mixing area, those traces of old mixtures may work their way into fresh mixtures the next time you paint. And that film of color will develop gradually into a crust that impedes the action of your brush or knife.

Saving Color. As long as you clean the central mixing area, there's nothing wrong with leaving the little mounds of wet color around the edges. Just wipe away any mixtures that may have accumulated around the mounds—leaving bright, fresh color for your next session. If you're planning to paint the next day—or within the next few days—the little piles of color on your palette will stay wet for your next painting session. If they start to dry out, they tend to form a leathery skin on the surface but contain moist color within. You can just puncture the leathery skin, peel it away, and work with the fresh color inside. If you're using a tear-off paper palette, you can simply peel away the top sheet; scoop off the mounds of moist color with your knife; transfer them to the next fresh sheet; then toss away the soiled sheet. If you're not planning to paint again for a week or more, discard the unused color and begin with a clean surface next time.

Care of Tube Colors. By the time you're finished painting, many of your tubes will be smeared with wet color. Wipe them clean with a rag or a paper towel so that you can read the labels and identify the colors the next time you paint. It's terribly frustrating to scramble around among paint-encrusted tubes trying to figure out which is which. Be particularly careful to clean the necks of the tubes and the insides of the caps so that they'll screw on and off easily. You'll also get more paint out of the tube if you roll the tubes up from the end instead of squashing them flat.

Care of Brushes. Don't just rinse the brushes in turpentine or mineral spirits, then wipe them on a newspaper, and assume that they're clean. No matter how clean the brushes may look, these solvents always leave a slight residue on the bristles. Eventually the residue builds up and stiffens the bristles so that they're no longer lively and responsive to your touch. After rinsing the brushes in a solvent and wiping them on newspaper, you *must* take the time to lather each brush in the palm of your hand. Use a very mild soap with lukewarm water. Keep lathering and rinsing in water until there's no trace of color in the suds. Be sure to work the lather up the bristles to the ferrule—the metal tube that holds the bristles. Then rinse away every bit of soap. Don't be discouraged if the bristles still look a bit discolored after repeated latherings. A very slight hint of color usually remains. But if you've lathered the brushes until the *suds* are snow white, you've removed all the color that will come out.

Care of Knives. The top and bottom surfaces of your palette knife and painting knife blades should be wiped clean and shiny. Use a rag or a paper towel. Don't overlook the edges and tips of the blades—wipe them too. With repeated use, these edges tend to become sharper, so wipe them with care. If they get too sharp, you can blunt them with the same kind of abrasive stone that's normally used for sharpening knives.

Care of Fluids. In the same way that you wipe your tubes clean after a painting session, wipe your bottles of oil, turpentine, and painting medium so that you can read the labels. Before you screw on the caps, wipe the necks of the bottles and the insides of the caps so that they won't stick. Screw on all caps very tightly so that your turpentine or mineral spirit won't evaporate, and your oil won't dry out.

Rags, Newspapers, and Paper Towels. By the end of the painting session, you'll probably have quite a collection of paint-stained rags, paper towels, and newspapers. Don't let this debris accumulate. Get it immediately into a tightly sealed metal container. Then get it out of the house! Remember that if oily rags and papers are left long enough, they gradually absorb oxygen and ignite by spontaneous combustion.

Safety Precautions. None of the painting materials recommended in this book are serious health hazards, but several can be mildly toxic. Oil paints in general—and the cadmium colors in particular—ought to be kept out of your digestive system. While you're painting, some color will always end up on your hands. For this reason, it's important to avoid eating or smoking while you paint. And be sure to wash your hands thoroughly with mild soap and water at the end of the painting session. Unlike many solvents, turpentine and mineral spirits don't produce deadly fumes. But it's still a good idea to work in a ventilated room: an open window or skylight will send those fumes out into the open air, rather than through the house. Although other solvents such as gasoline (petrol in Britain), kerosene (paraffin in Britain), and other industrial compounds are sometimes recommended for use in the studio, they're usually flammable or toxic or both. So stick to turpentine or mineral spirits.

Washing. Rinse your brush in turpentine or mineral spirits, dry it on newspaper, then lather it with mild soap and lukewarm water in your palm.

Shaping. Keep lathering and rinsing until the suds are snow white. Wash out the bristles with clear water. Press the damp bristles into a neat shape.

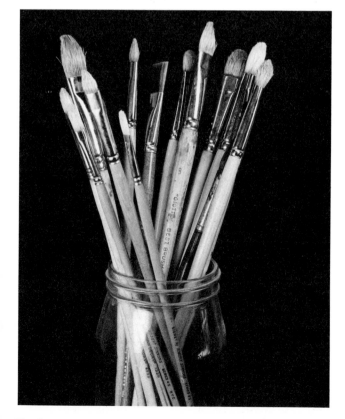

Drying. While they're drying, store brushes in a jar, bristle end up. If you use your brushes often, store them in the jar between painting sessions.

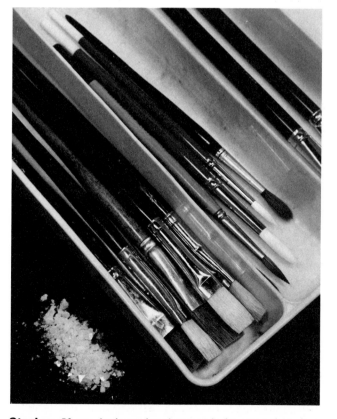

Storing. If you don't use brushes regularly, store them in a shallow box (or a silverware tray like this one) and put them in a drawer with moth-killing crystals.

Permanent Colors. Looking at the dates on the oil paintings in the world's great art museums, you know that an oil painting can last for centuries. But a picture is only as durable as the materials used to paint it. To begin with, not all colors are equally permanent—some will crack or change color over the years. There are also some colors that form unstable chemical combinations: that is, they deteriorate when they're mixed with certain other colors. So the lesson is: stick to permanent colors. All the colors recommended in this book are extremely durable when used by themselves or in combination with other colors. There's just one exception. Ivory black has a tendency to crack when it's used straight from the tube, although it's fine when you use it in mixtures with other colors. So make a point of blending ivory black with at least one other tube color. If you'd like to experiment with other colors, always check the manufacturer's literature to find out how permanent that color will be.

Permanent Painting Surfaces. A painting is only as durable as the surface it's painted on. Professional oil painters normally work on stretched canvas: high-quality linen or cotton nailed to a rectangular framework of well-seasoned wood. Or they work on the hardboard panels that have replaced the wood panels used by the old masters. In either case, the canvas or hardboard is coated with white oil paint or gesso, applied either by the manufacturer or by the artist himself. Yes, canvas boards are the most popular surface among Sunday painters and students. They're durable enough for you and your family to enjoy for many years. But the canvas is inexpensive, and the cardboard backing will eventually start to crumble. So when you start thinking about posterity, switch to stretched canvas or hardboard panels.

Varnish. Oil paintings—unlike watercolors—aren't exhibited under glass. The leathery surface of a dried oil painting is a lot tougher than a sheet of paper. However, an oil painting is normally protected by a coat of varnish that serves the same purpose as a sheet of glass. When you go shopping for varnish, you'll probably see some bottles labeled *retouching varnish* and others labeled *picture varnish*. They have different functions.

Retouching Varnish. Most oil paintings are dry to the touch in a week or so, but it takes at last six months for the paint to dry all the way through. As soon as the surface feels dry, you can protect it with *retouching varnish*. This is a thin mixture of solvent and a little resin such as damar or mastic. The solvent evaporates, leaving behind just enough resin to preserve the freshness of the colors—and perhaps brighten the colors a bit—while the paint film continues to dry. Apply retouching varnish with a soft nylon housepainter's brush. Work with parallel strokes. Don't scrub back and forth or you'll disturb the paint, which isn't as dry as it looks.

Final Varnish. The bottle that's labeled *picture varnish* is a thicker version of the same formula used to make the retouching varnish. The main difference is that the picture varnish contains a lot more resin. This is the final varnish that protects the surface of the picture like a sheet of glass that protects a watercolor. Most oil paintings are ready for a coat of picture varnish after about six months. But if you paint with very thick strokes, they'll take longer to dry all the way through, and it's best to wait as long as a year. Again, use a soft nylon housepainter's brush and work with parallel strokes. Move the brush in one direction only—from top to bottom or from one side to the other. Work on a clean, dust-free, horizontal surface and leave the painting there until the varnish dries to a smooth, glassy film. Don't scrub the brush back and forth, or you'll disturb the smooth surface of the varnish.

Framing. The design of a frame is a matter of taste. It's up to you to decide whether you like a frame that's ornate or simple, colorful or subdued. But remember that the frame also preserves the picture. If you choose a wooden frame, make sure that it's thick and sturdy enough to protect the edges of the canvas from damage. The frame should also be rigid enough to keep the canvas from warping. If you prefer to frame the picture in slender strips—rather than the thicker, more traditional kind of frame—rigid metal strips will provide better protection than wood. If the painting is on stretched canvas, it's a good idea to protect the back by tacking or stapling a sheet of cardboard to the wooden stretcher bars.

Storing Oil Paintings. If you're not going to hang paintings, store them vertically, not horizontally. Don't stack one on top of the other like a pile of magazines. Find some closet where the canvases or panels can be stored upright, standing on their edges. The front of one painting should face the back of another; that way, they don't stick together if the paint is still slightly soft. Remember that stretched canvases are particularly fragile; handle them so that the corner of one canvas won't poke a hole in the face of another.